KEIGHLEY & WORTH VALLEY RAILWAY

THROUGH TIME

Mark Bowling

AMBERLEY PUBLISHING

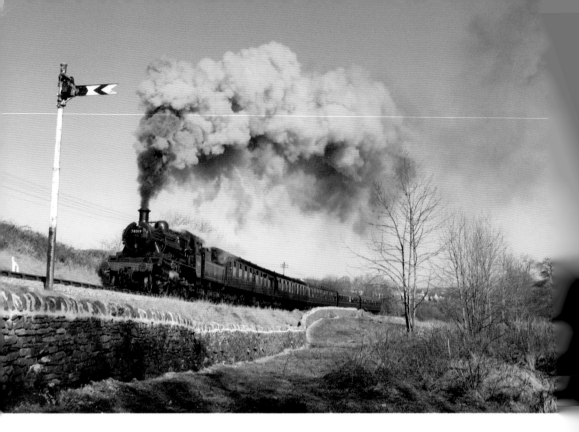

BR Standard Class 2 No. 78019
BR Standard Class 2 No. 78019 works hard up the incline between Ingrow Tunnel and Damems station during the Spring Gala on 2 March 2013.

First published 2014

Amberley Publishing
The Hill, Stroud, Gloucestershire, GL5 4EP
www.amberley-books.com

Copyright © Mark Bowling, 2014

The right of Mark Bowling to be identified as the Author of this work has been asserted in accordance with the Copyrights, Designs and Patents Act 1988.

ISBN 978 1 4456 3581 1 (print)
ISBN 978 1 4456 3597 2 (ebook)

British Library Cataloguing in Publication Data.
A catalogue record for this book is available from the British Library.

Typesetting by Amberley Publishing.
Printed in Great Britain.

Introduction

On 15 April 1867, the branch line from Keighley to Oxenhope was opened. The line itself was built by local mill owners; however, the operation of trains was franchised to the Midland Railway, who were already operating the nearby line from Leeds and Bradford to Skipton. In 1881, the Midland Railway reached an agreement with the Great Northern Railway, who were constructing a line from Bradford to Keighley. The companies shared the Worth Valley track between Keighley station and Keighley (Great Northern Junction), doubling this section of track, and widening bridges 1 to 4. Eventually, the Midland Railway bought out the Keighley & Worth Valley Railway (KWVR), operating the line until 1924, when they were amalgamated into the London, Midland & Scottish Railway. The line became part of British Railways (BR) in 1948.

Built on a steep gradient, the line had been built to serve the local textile industry, with many woollen mills along its 5-mile length. The mills were steam-powered and relied on the railway to bring in hundreds of tons of coal each week to keep the weaving looms working. Belching steam and smoke, the trains would have been made to work hard through the Worth Valley, creating a dramatic scene. As well as transporting goods in and out of the local mills, the railway also served local people with passenger services.

With the textile industry in decline, the branch line was deemed to be uneconomic by Dr Beeching, and on 31 December 1961 the line was closed to passengers (goods services continued until 18 June 1962). On 18 June 1962, a passenger train headed by 3F No. 43856 worked the branch for the very last time before its closure. Local opposition to the closure was fierce, and a preservation society was formed. The society formed a company, bought the line outright, and leased access into Keighley station. Joining forces with railway enthusiasts, the society fought a long battle to reopen the line. On 29 June 1968, the line was finally reopened to passengers.

Although many of the mills that once stood alongside the line have now been demolished, the remaining buildings provide a powerful backdrop to the line. With preserved trains being made to work hard up the inclines, the KWVR can create a believable recreation of a period steam railway that runs through beautiful countryside and past dark industrial mills, appealing to enthusiasts, while still being able to provide a mode of transport for local people.

The Line

The 5-mile route runs from Keighley to Oxenhope. Along the way, the line passes through four intermediate stations at Ingrow (West), Damems, Oakworth and Haworth. From Keighley, the line rises throughout its route to Oxenhope on an average gradient of 1 in 70. The steepest gradients are at Keighley Curve and between Ingrow Tunnel and Damems station, both having a gradient of 1 in 56.

At Keighley station, the facilities are shared with the national railway network, the KWVR occupying platforms 3 and 4. Locomotive run-round facilities are available at both Oxenhope and Keighley. Keighley station also provides a connection to the national rail network.

A passing loop is located at Damems Junction, allowing two-train operation. There is also a goods loop at Haworth, but this is currently out of use due to signalling issues.

Reopening and the Preservation Era

Having battled for six years, the KWVR became the first ex-BR line to become privately owned. Remarkably, having agreed a deal to purchase the railway, the society were allowed to pay the money over a twenty-five-year period with no interest. The final $\frac{1}{25}$ instalment was only paid in 1992.

Prior to reopening, the society had purchased diesel railcars, a diesel locomotive and several steam locomotives and carriages. A Light Railway Order was acquired by BR in 1967 and transferred to the KWVR on 27 May 1968. The first public trains ran on 29 June 1968. The first trains were hauled by Ivatt 2MT No. 41241 and USA 0-6-0T No. 72. Both locomotives were lettered KWVR, with the Ivatt painted in crimson lake livery and the USA tank in golden brown with a silver smokebox.

During the six years that the line was closed, passengers and freight had found other means of transport. Despite this, a diesel weekend morning service proved popular with local shoppers, and steam services have gradually increased over the years. Local residents can also apply for a pass that gives them reduced prices and provides a viable alternative to the bus.

In the early days, the railway infrastructure was in a mess, vandalism was rife, and many structures had been left to rot. Ingrow (West) station building was in such a state of disrepair that it had to be demolished. Eventually, in the 1980s, a replacement was built. Such has been the progress since the 1960s that operating days are now close to 200 per year, and the KWVR has developed into one of the country's premier heritage railways. This is surely testament to the hard work and dedication of the volunteer workforce.

The line was reopened as a recreation of a 1950s branch line. Not only has this proved popular with visitors, it has also been the choice of many filmmakers and television producers. Over the years, the railway has appeared in a wide variety of productions, including *Sherlock Holmes*, *Last of the Summer Wine*, *Yanks*, *Some Mothers Do 'Ave 'Em Em*, *Poirot*, *Born and Bred*, *The Royal*, *A Touch of Frost*, *Where the Heart Is*, *Treasure Hunt*, *Songs of Praise*, *Great British Railway Journeys* and Pink Floyd's *The Wall*. Most famously of all, the 1970 version of Edith Nesbit's *The Railway Children* was filmed in and around Oakworth station – a major boon to the KWVR. In 1969, the year before the film was released, the railway carried 71,000 passengers. The film created so much interest that, in 1971, 125,000 passengers were carried. Passenger numbers declined seriously thereafter, but since the abandoning of KWVR liveries and the rebranding as a 1950s BR Midland region branch, the railway's fortunes have seen a steady rise.

Attention to detail is evident throughout the railway, with coal fires, gas lamps and period paraphernalia evident at every station. It is little wonder that the railway has become such a major tourist attraction.

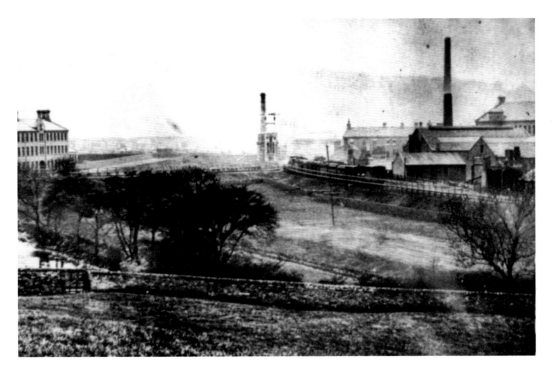

Keighley Station

The KWVR built a station at Keighley in the 1860s. Opened in 1867, this very early photograph (courtesy of KWVR Archive) shows the station in the 1870s. The station was rebuilt on its current site in 1883. The present station has changed little over the years, and can be seen in the November 2013 picture below, which shows the KWVR side of the station.

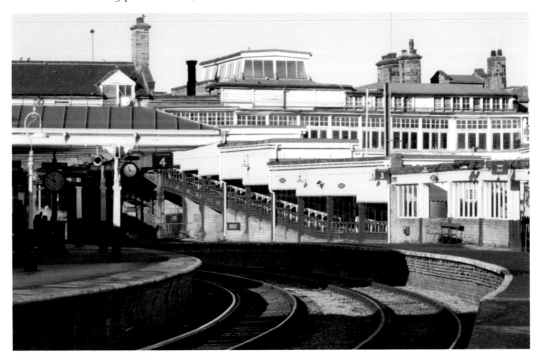

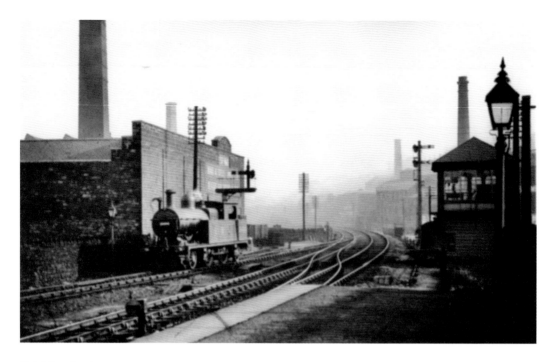

Keighley Station

In the 1930s, the railway would have been extremely busy, with coal in and textiles out of the many mills that surrounded the area. The picture above (courtesy of Jack Adams/KWVR Archive) shows ex-L&YR Radial Tank Class 5 2-4-2T running into the bay platform light engine. The picture below, taken in February 2012, shows ex-London & North Western Railway (LNWR) Coal Tank 0-6-2T standing at Keighley station at twilight. Both locomotives were built in the late nineteenth century and, other than colour, there is little to suggest that one image is so much more recent then the other.

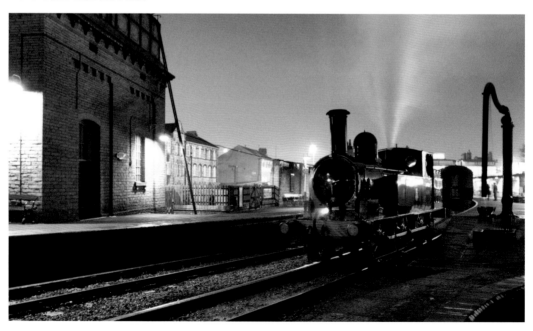

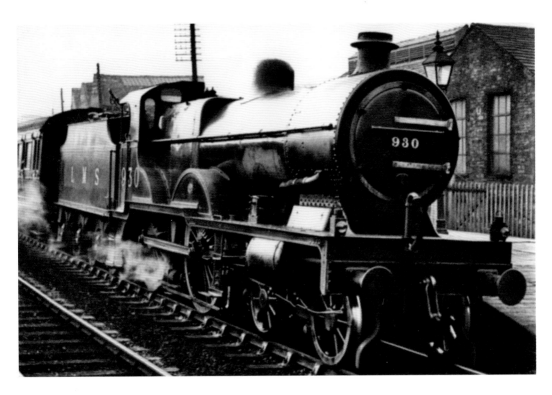

Keighley Station: The Main Line

Keighley station serves both the branch line and the main line from Leeds and Bradford to Skipton. Dating from the 1930s, the picture above (courtesy of Jack Adams/KWVR Archive) shows LMS Fowler Compound 4-4-0 No. 930 waiting to depart with an express for Leeds and Bradford. Below is an image from 2013 of the same location. With the line now electrified, a Northern Rail service from Skipton to Leeds waits at platform 1.

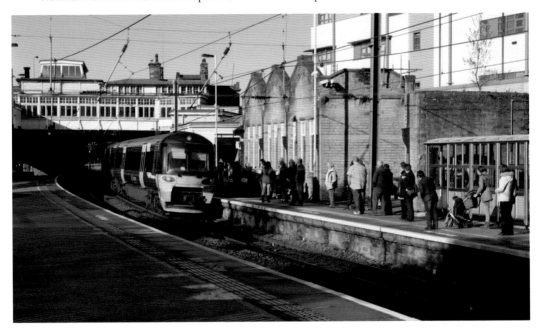

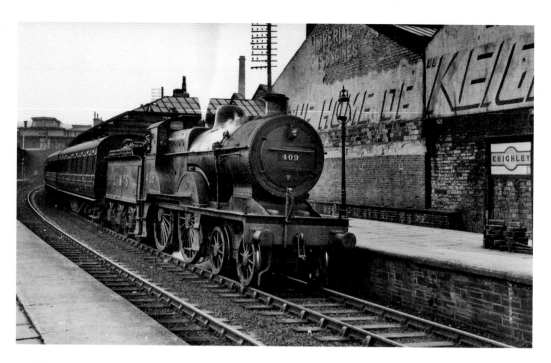

Keighley Station

Moving forward a decade from the photograph on page 7, the image above (courtesy of W. A. Camwell/KWVR Archive) from August 1947 shows LMS 4-4-0 No. 409 on the Skipton to Bradford Forster Square service. Below, we can see GNR Ivatt 0-6-2T with a local passenger train at platform 3 (courtesy of N. E. Stead/KWVR Archive). This is a good example of a typical 1950s branch line train.

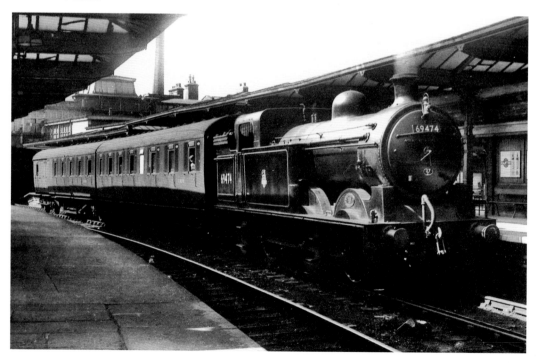

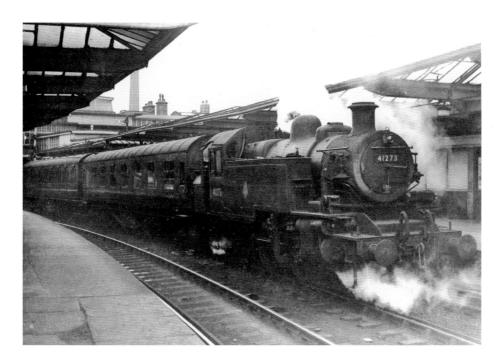

Keighley Station

The 1957 image of an Ivatt Class 2MT 2-6-2T on a push-pull service to Oxenhope (courtesy of John A. Pitts/KWVR Archive) is typical of the last steam trains to operate on the branch prior to preservation. The 2009 picture below shows a train of wooden-bodied vintage carriages double headed by ex-L&Y *Ironclad* No. 957 and Ivatt Class 2MT No. 41241. Bought from Skipton in 1967, No. 41241 arrived under its own steam and was used on the reopening train on the branch line in 1968. This makes an interesting comparison with the 1957 photograph.

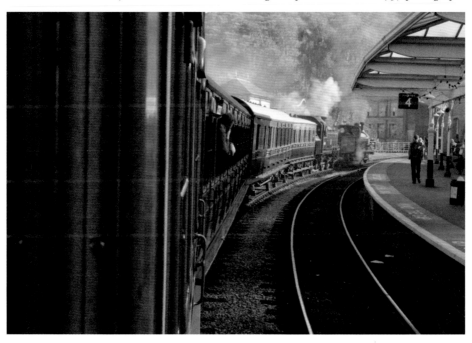

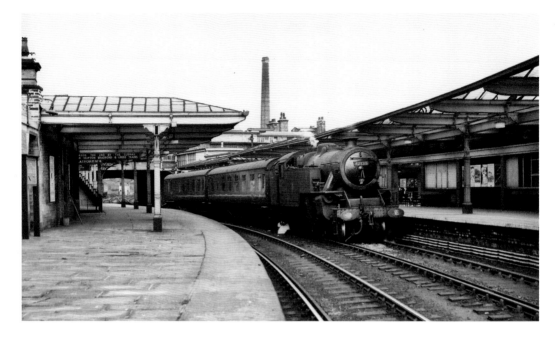

Keighley Station

Dating from August 1956, the picture of a Fairburn Class 4 2-6-4T with a two-coach train for Oxenhope (courtesy of K. Houghton/KWVR Archive) gives a good panoramic view of platforms 3 and 4. Note how empty the platforms are. The 1960s picture below shows ex-London & North Eastern Railway (LNER) tank No. 69459 at Keighley station, having arrived via the Great Northern (GN) line (courtesy of N. E. Stead/KWVR Archive). Things are really starting to look run down by this stage. The train is grimy and the station canopy no longer has any glass in it.

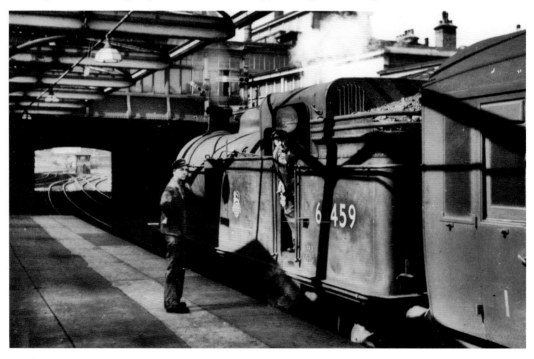

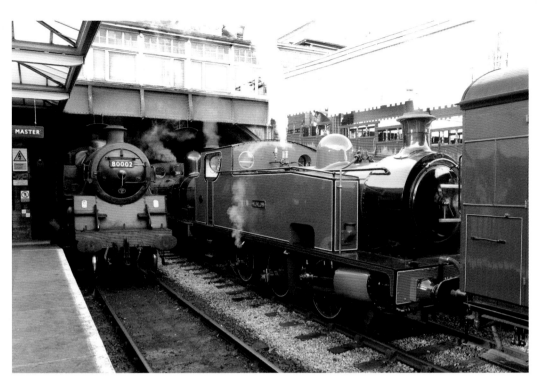

Keighley Station

Both pictures show Keighley station in the twenty-first century. The top image is from a busy gala weekend in 2010. Note the clean, well-maintained trains and the beautifully restored station complete with all-glass panels in the canopy. The picture to the right is from 2009 and shows LMS 3F Jinty No. 47279 making a dramatic departure for Oxenhope surrounded by smoke and steam that virtually obscures the view of the station behind.

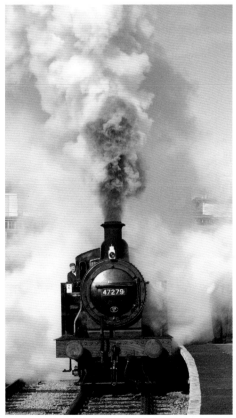

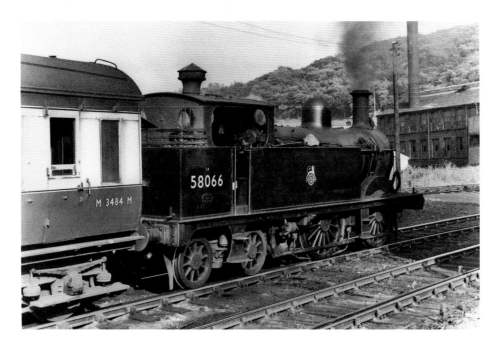

Keighley Station Throat

Above: Johnson 0-4-4T, dating from 1892, approaches platform 3 at Keighley with a local passenger train in 1955 (courtesy of W. H. Foster/KWVR Archive). The Johnson 0-4-4 tanks were typical of the locomotives used for passenger services on the branch. *Below:* BR Class 25 Type 2 mainline diesel locomotive No. 25059 approaches platform 3 with a normal service in June 2013. This is the same location as above, but the photograph is taken from the approach road. It is interesting to note that although the railway buildings have all been lovingly restored, some of the surrounding mills are in a state of dereliction.

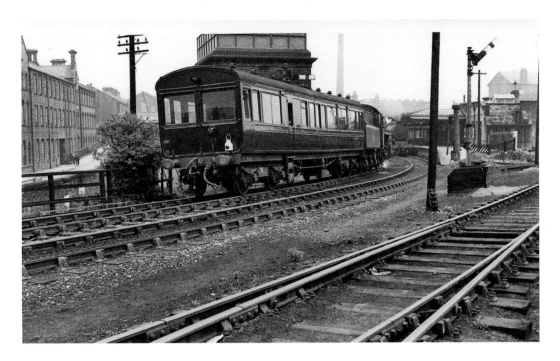

Keighley Station Throat

In May 1958, an engineer's saloon enters Keighley station after inspecting the Worth Valley Branch (courtesy of P. Sunderland/KWVR Archive). The area surrounding the station throat still has a familiar look to it in the picture below. However, if you look carefully through the smoke, you can see the new college building in the background. Many of the other buildings remain pretty much the same as they were in the 1950s and '60s.

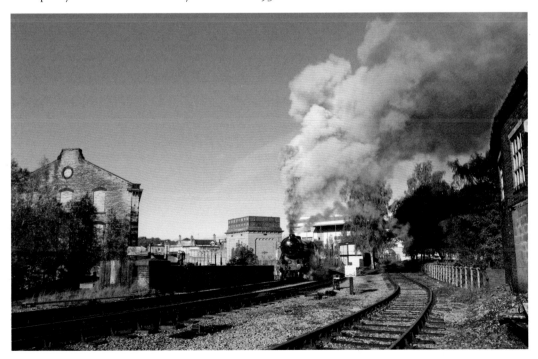

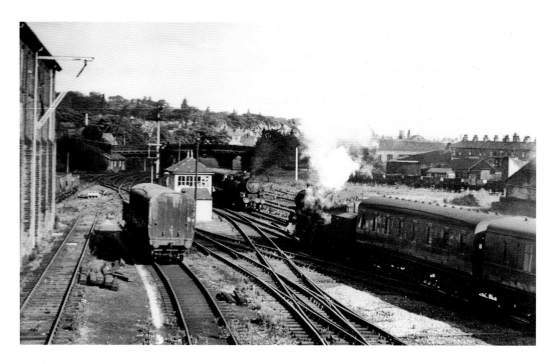

Keighley Station Approach

Above: In this 1965 picture, Stanier Class 4 2-6-4T and Ivatt Class 4 2-6-0, both on local passenger trains, pass at Keighley. Between the locomotives, you can see that the double junction is being removed, isolating access onto the KWVR branch line (courtesy of R. J. Carmen/KWVR Archive).
Below: Standard 4 Tank No. 80002 leaving Keighley station platform 4 and heading onto the Great Northern Straight in April 2011.

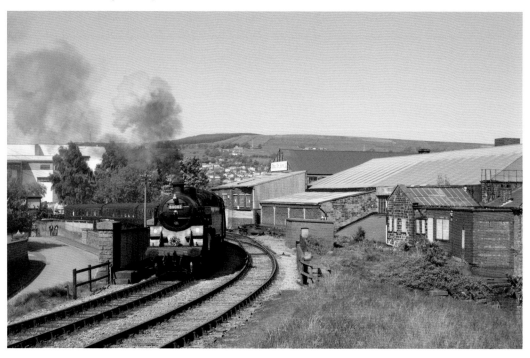

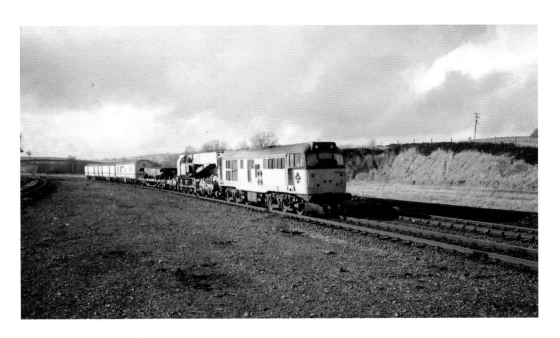

Keighley Turntable

After reopening in 1968, the railway operated for many years without locomotive turning facilities. This was eventually rectified in 1989 when the turntable from Garsdale on the Settle to Carlisle line was acquired. The picture above shows BR Class 31 No. 31200 with the Carlisle crane and the turntable from Garsdale approaching Hellifield en route to Keighley on 26 February 1989 (courtesy of Chris Hulme/KWVR Archive). The picture below shows Keighley station and the newly installed turntable from May 1990 (courtesy of Robin Stewart-Smith/KWVR Archive). Note that the track has not yet been laid – perhaps this is just as well, as a young lady seems to be quite comfortably sitting on the deck.

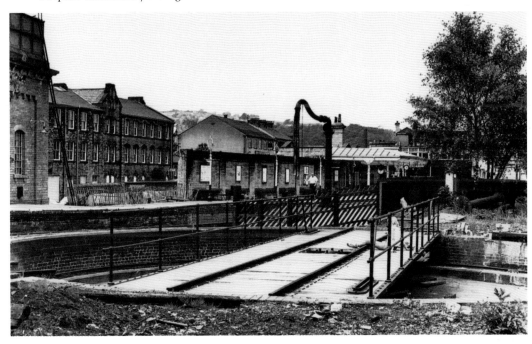

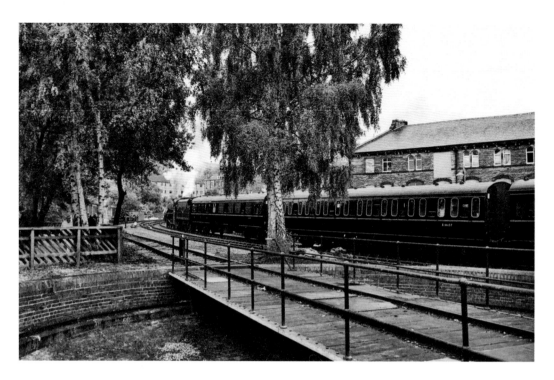

Keighley Turntable

Now fully operational, the turntable provides useful facilities for the KWVR. The picture above, taken from the other end of the turntable in October 2013, shows Black 5 No. 45305 leaving with a train for Oxenhope, providing an interesting comparison with the shot on the previous page. Little seems to have changed in over twenty years, an impression reinforced by the photograph being black and white. The picture below of Waggon und Maschinenbau M79964 railbus leaving Keighley station in November 2013 shows the turntable in its setting within the station area.

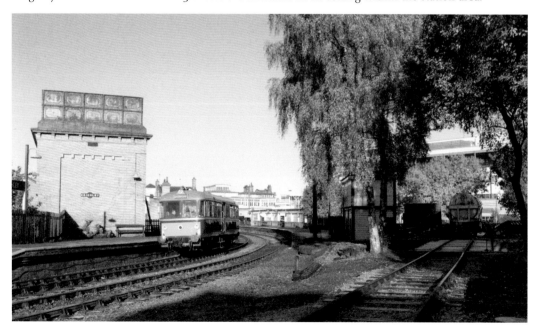

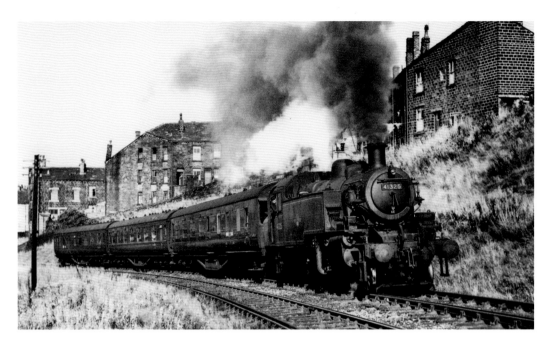

Keighley Curve and Keighley Bank

Immediately after leaving Keighley station, the line rounds a sharp curve before starting the steep climb up Keighley Bank. In pre-preservation days, there was a junction at this point; Midland trains would head for Oxenhope via Ingrow (West) station, while Great Northern Trains would head to Ingrow (East). The picture above, from the 1950s, shows push-pull-fitted Ivatt Class 2MT No. 41326 rounding the curve with a three-coach train and making a spirited climb up Keighley Bank (courtesy of KWVR Archive). Below, we can see LMS 4F No. 43924 and USA S160 No. 5820 *Big Jim* double heading up the incline on 11 January 2014. *Big Jim*, wearing BR black livery and No. 95820 had just returned to service and was on its first passenger service since overhaul.

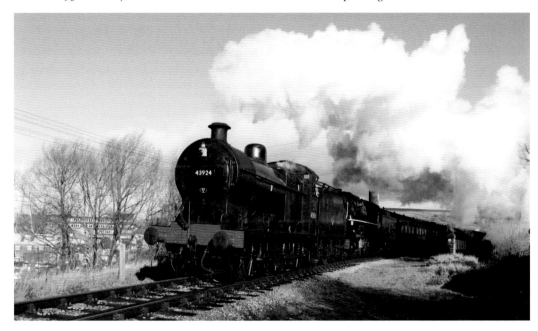

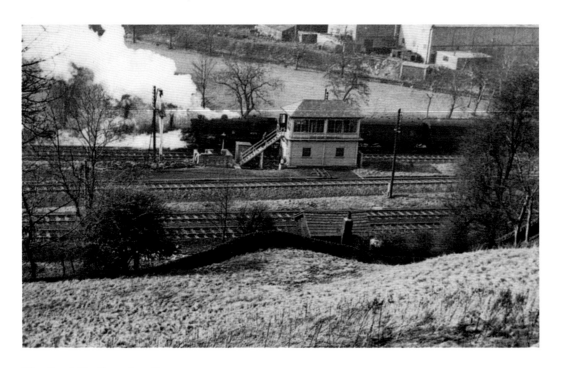

The Great Northern Junction

Above: This picture gives a good view of the junction area in the 1950s. Ivatt Class 2MT No. 41273 is on the single-track Worth Valley line, having just exchanged tablets at the GN Junction. At the front is the double-track Great Northern Queensbury line into the Goods Yard. The centre line is the connecting spur (P. Sunderland/KWVR Archive). *Below:* In April 2011, timetabled locomotive, L&Y *Ironclad* No. 957 had just failed at Keighley. Class 20 No. 25059 was attached, so the pair then double headed the train, as seen here on the GN Straight.

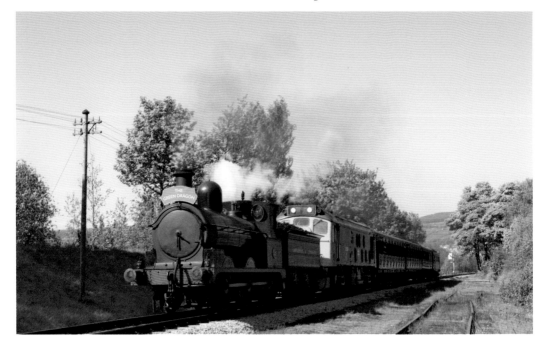

The Great Northern Straight
In the picture above, an Ivatt Tank heads away from the GN Junction towards Ingrow (West) with a Worth Valley service in the 1950s (courtesy of KWVR Archive). The picture below shows LNWR Coal Tank No. 1054 with a vintage train in the same location on 17 July 2013.

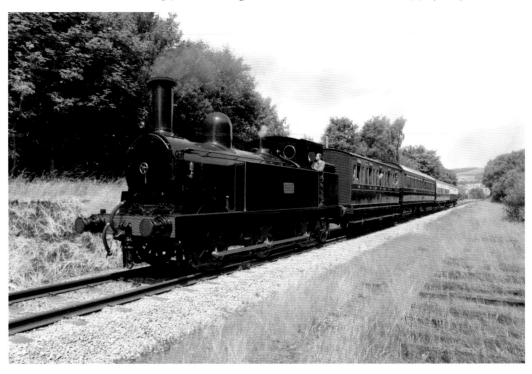

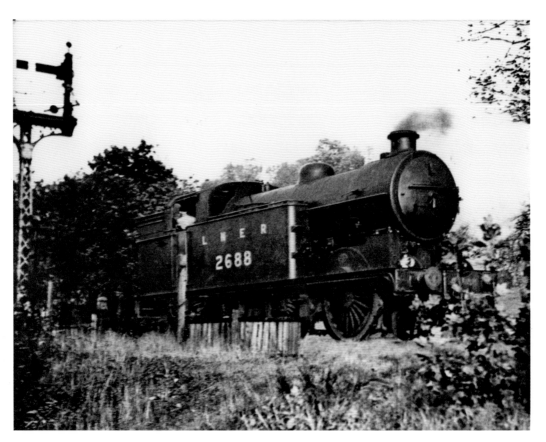

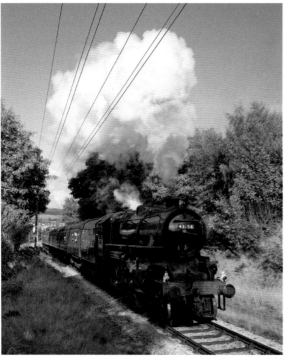

The Great Northern Junction
The picture above, from the 1930s, shows LNER 0-6-2T No. 2688 running down from Ingrow (East) towards the GN Junction (courtesy of Jack Adams/KWVR Archive). This line no longer exists. The image below from 2012 shows Ivatt Class 4 *Flying Pig* No. 43106 climbing away from Keighley roughly parallel to the first picture, but on the Midland line.

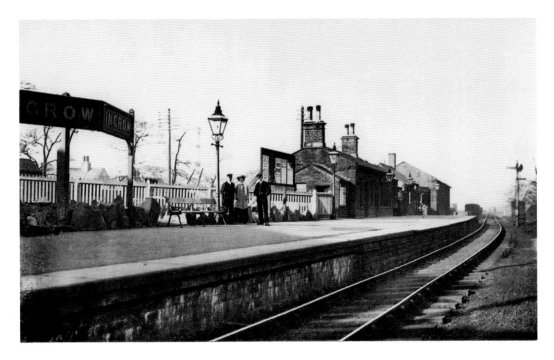

Ingrow (West) Station

The next station along the line from Keighley is Ingrow (West). The picture above shows the station in Midland Railway days in 1906 (courtesy of KWVR Archive). Everything looks very smart, including the people posing on the platform. By the 1970s, Ingrow (West) station was derelict. The picture below shows the station after the demolition of the main building. All that is left is the old lamp room, with the old goods shed beyond. Between the two buildings where the cars are parked is the old slurry depot (courtesy of C. G. Smyth/KWVR Archive).

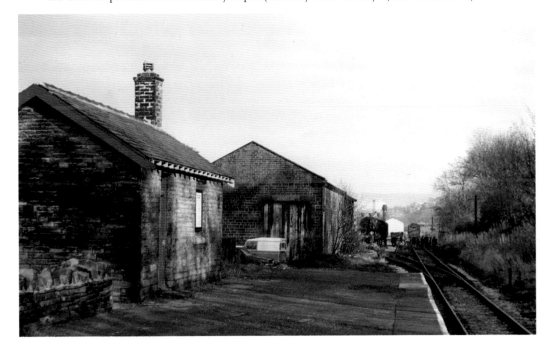

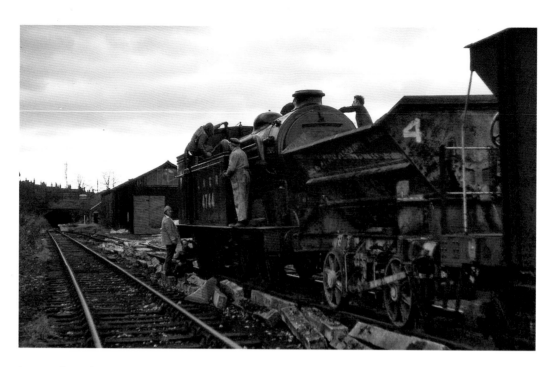

Ingrow (West)

Of all the stations on the line, Ingrow (West) required the most work. Apart from rebuilding the station building, the whole goods yard area needed redevelopment. In the picture above from the 1970s, LNER N2 0-6-2T No. 4744 stands in Ingrow (West) Yard with a tipper wagon behind as work progresses (courtesy of C. G. Smyth/KWVR Archive). In contrast, the picture below shows a 4F pulling into the rebuilt station in 2013. Apart from the man and child on the platform, there is little else to date the picture to the twenty-first century.

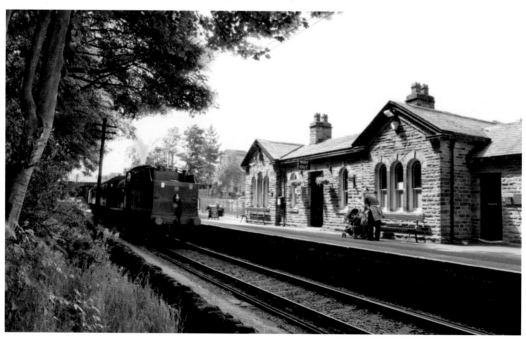

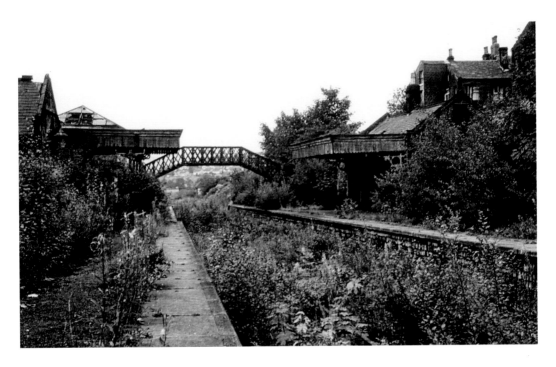

Ingrow (East)

The Great Northern Railway also ran into Ingrow, but their station was at Ingrow (East). Now completely gone, the picture from 1965 above shows the station looking derelict, overgrown and totally neglected. In contrast, the picture below shows BR Class 25 Type 2 No. 25059 approaching Ingrow (West), passing under a well maintained bridge, surrounded by tidy fences and embankments, and running on newly ballasted track.

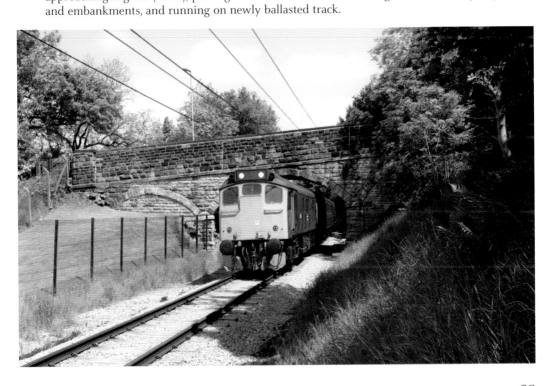

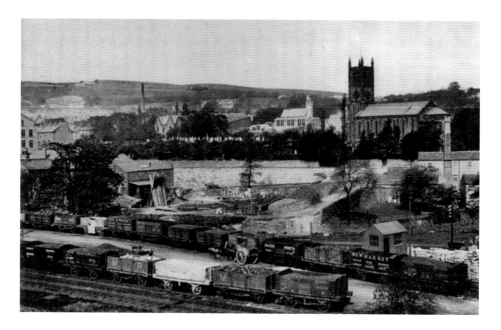

Ingrow (West) Goods Yard

Ingrow (West) had a busy goods yard, as can be seen in the image above. This picture, taken in the 1900s, gives a good view of not only the yard, but also the surrounding area (courtesy of KWVR Archive). In the early days of preservation, Ingrow (West) was used as a request halt as the station building had been badly vandalised. In 1989, the newly rebuilt station building was reopened. The goods yard area now provides a home for the Museum of Rail Travel. The museum is run by the Vintage Carriages Trust and houses some fantastic Victorian carriages. The Bahamas Locomotive Society also has a museum and workshop at this location. The picture below from the 1970s shows GWR 0-6-0PT No. 5775 in LT livery passing this area before it was redeveloped.

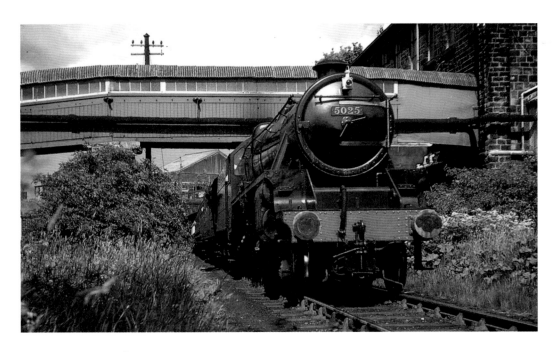

Ingrow Tunnel to Damems

Trains leave Ingrow (West) station and immediately enter the 150-yard-long Ingrow Tunnel. On exiting the tunnel, the land runs alongside a river and becomes more rural in nature as it climbs steeply towards Damems. Taken at this location in the 1960s, LMS Black 5 No. 5025 exits the tunnel and passes underneath the now demolished bridge 10 with a service from Keighley (courtesy of J. Phillips/KWVR Archive). This is one of the steepest sections on the line and locomotives are made to work hard as they exit the tunnel, as can be seen in the picture below of LMS 4F No. 43924 leaving Ingrow Tunnel on a crisp wintry day in March 2013.

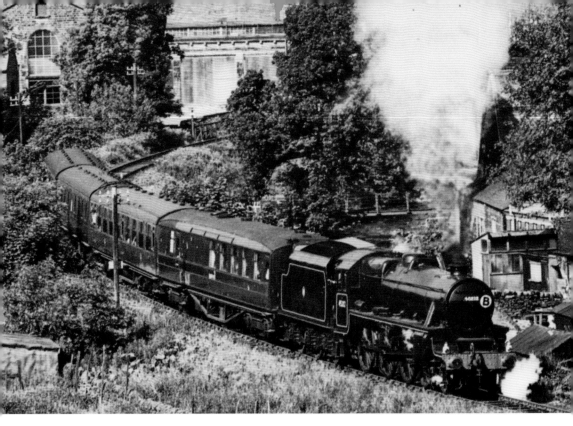

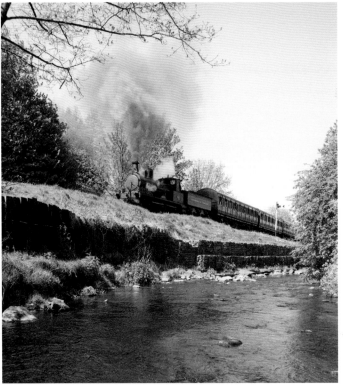

Cloughs Mill

Trains run alongside the river before starting their final ascent into Damems station. The picture above shows LMS Black 5 4-6-0 No. 45212 between Cloughs Mill and Damems. Note the large Cloughs Mill in the background and the allotments in the foreground. There is also a footbridge across the river (courtesy of J. S. Clough/KWVR Archive). Compare this with the picture to the left of L&Y Barton Wright 0-6-0 *Ironclad* with the Scotch Flyer service on a *The Railway Children* recreation weekend in April 2011. I was actually standing in the river to take this shot.

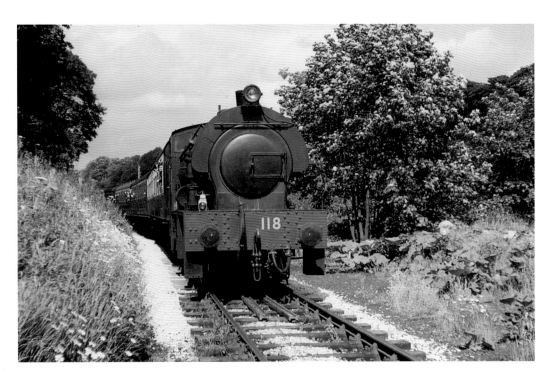

Final Approach to Damems

Above: In the 1970s, the railway used a lot of industrial tank engines. Rounding the corner on the approach to Damems is Austerity 0-6-0ST 118 *Brussells* (courtesy of C. G. Smyth/KWVR Archive).
Below: Standard 4 Tank No. 80002 approaches Damems station on a beautiful early spring gala morning on 29 March 2013.

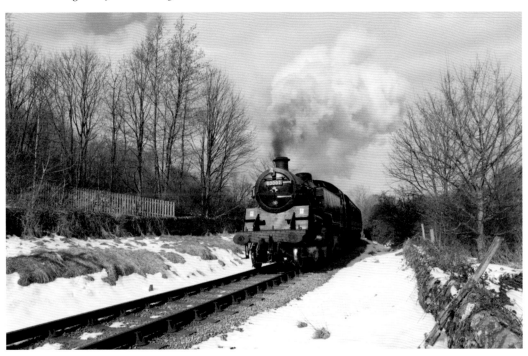

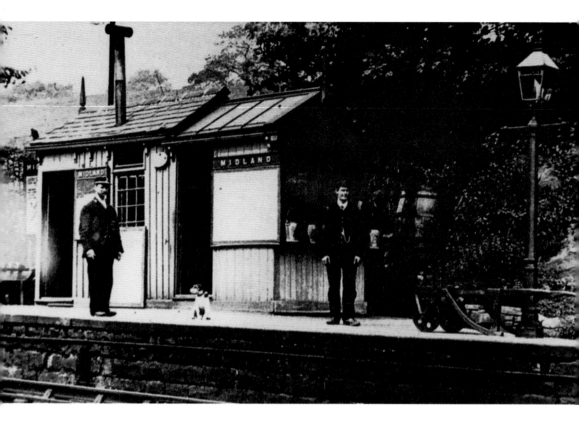

Damems Station

Damems station has the distinction of being Britain's smallest station. Boasting a ticket office, waiting room, toilet, signal box and stationmaster's house, Damems is not just a halt. It is officially the smallest 'full-size' station in Britain.

Opened in 1847 to serve a nearby mill, the platform has been just one coach long throughout its life. Originally, there was also a siding where the house now stands. The early picture above (courtesy of KWVR Archive) shows the station as it was in the 1900s. Even the dog seems happy to pose for the photograph!

Closed in 1949, the station was run by Mrs Annie Feather from 1928 until closure. She lived in the station house, operating the signals from a ground frame in her front garden and opening the level crossing gates by hand. In 1971, a cabin was acquired from Earby on the Colne to Skipton line. The ground frame was moved from the garden into this cabin. In 1993, the station building was demolished as it had completely rotted. The new building was designed to look similar to the original Midland Railway station that we see above.

Damems station has been featured on television, most famously in the BBC series *Born and Bred*.

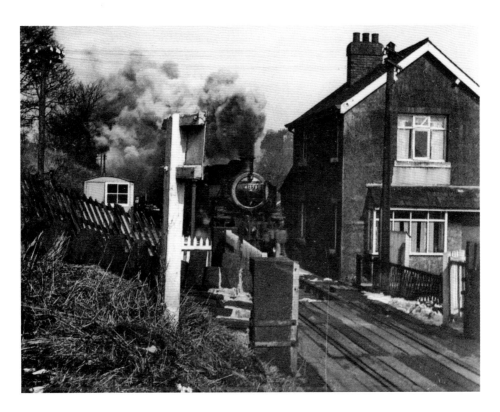

Damems Station

The picture above shows Ivatt Class 2MT No. 41273 passing through Damems with the
1.50 p.m. Saturday only service from Keighley to Oxenhope on 15 March 1958 (courtesy of
R. O. T. Povey/KWVR Archive).The same location can be seen below, as Standard 4 Tank
No. 80002 exits Damems with a service for Oxenhope in October 2011.

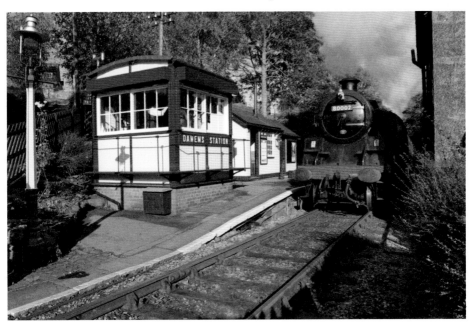

Damems

Above: This wide shot of GWR 0-6-0PT No. 5775 in London Transport livery passing through Damems shows how the area looked in 1974 (courtesy of C. J. Gammell/KWVR Archive). *Below:* This picture from June 2013 shows a panoramic view of BR Standard 4MT No. 80002 and prototype shunter D0226 *Vulcan* double heading a train through the area between Damems and Oakworth. This gives a good indication of the rural nature of this part of the line. The station is accessed via narrow lanes.

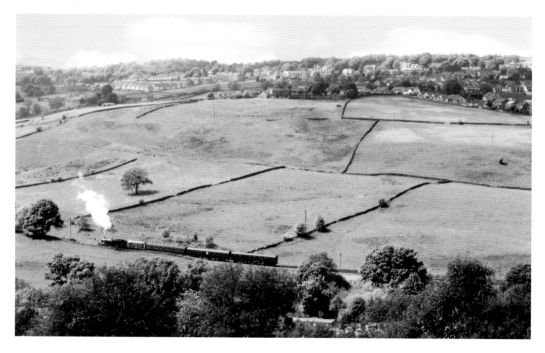

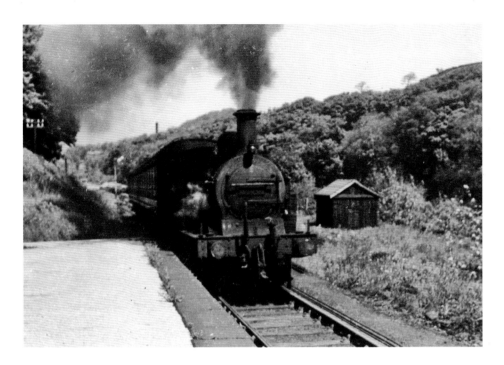

Damems

Above: In the 1950s, an ex-LMS 0-4-4T belching black smoke runs through Damems with a train for Oxenhope. *Below:* When was this picture taken? With nothing to date it, the picture could easily be an image from the 1930s or '40s. Actually, this dramatic picture of LNWR Coal Tank No. 1054 departing from Damems amid a cloud of smoke and steam was taken at a very wet gala weekend on 12 October 2013.

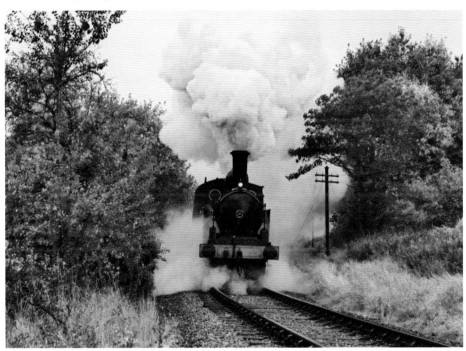

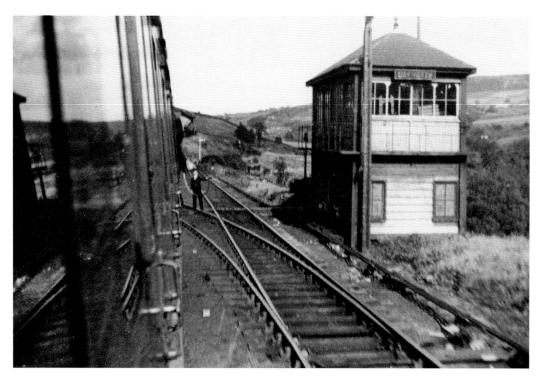

The Signal Box and Passing Loop

Passing facilities and token exchange took place at Oakworth prior to closure. The picture above, taken in the 1950s, shows the train driver of an auto train about to exchange tokens with the Oakworth signalman (courtesy of Hans-Peter Erismann/KWVR Archive). This area is opposite what is now the permanent way yard at Oakworth.

In preservation, a signal box and passing loop have been positioned at Damems Junction, as can be seen in the picture below. L&Y A Class No. 1300 and LMS 4F No. 43924 make a dramatic double-headed departure from the loop in late afternoon sunlight during a gala weekend in October 2012.

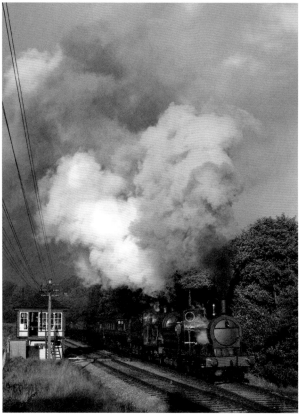

Damems to Oakworth

The pictures on this page show the area between Damems and Oakworth as it is now. In the picture above, BR Class 20s can be seen leaving Damems and heading towards Damems Junction during the diesel gala in April 2013. The picture below shows LMS 4F No. 43924 heading away from the loop on the way to Oakworth Bank.

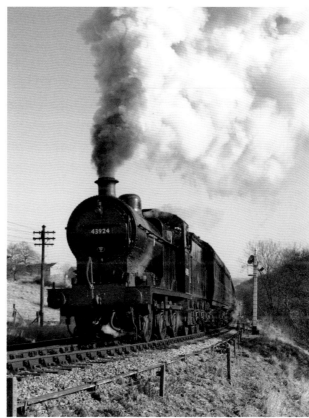

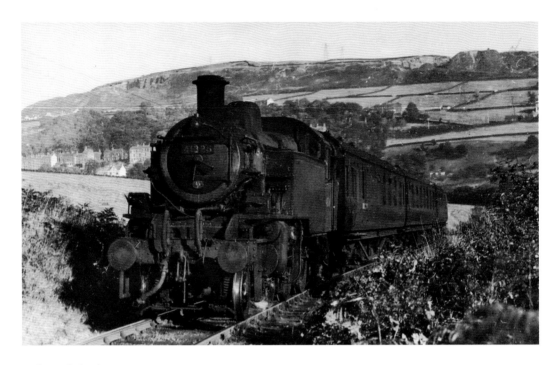

Oakworth Bank

Between Damems and Oakworth, trains climb the gradient past Oakworth Bank. This has now become one of the most popular photographic locations on the line, as trains are made to work hard through this section. Ivatt Class 2MT No. 41326 climbs towards Oakworth with a service to Oxenhope in the 1950s shot above (courtesy of P. Sunderland/KWVR Archive). In the March 2013 shot below, No. 80002 makes brisk progress up the bank. It is clear how little the location has changed in the intervening years.

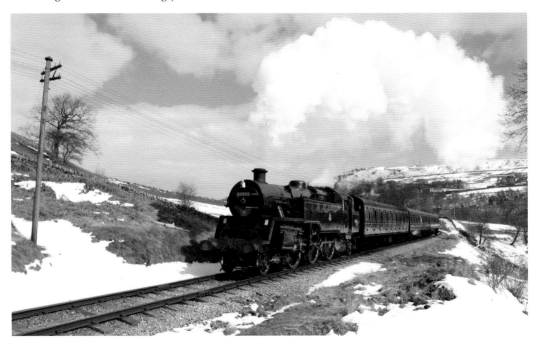

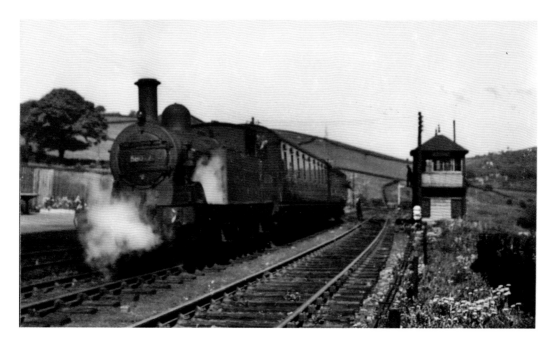

Approach to Oakworth

Trains continue their ascent of the gradient as they approach Oakworth station. The area remains rural and attractive all the way into the station approach. The 1950s picture above shows ex-LMS 0-4-4T unidentified in push-pull mode departing from Oakworth with the locomotive at the rear. Note the driver exchanging tokens with the signalman at the original signal box (courtesy of KWVR Archive). The picture below from November 2012 shows LMS 4F No. 43924 and its train heading towards the station. You can just pick out the start of the permanent way yard in the distance.

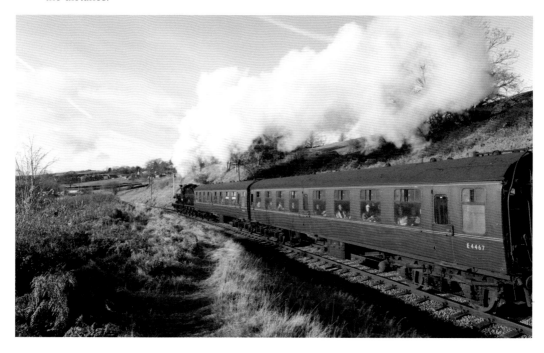

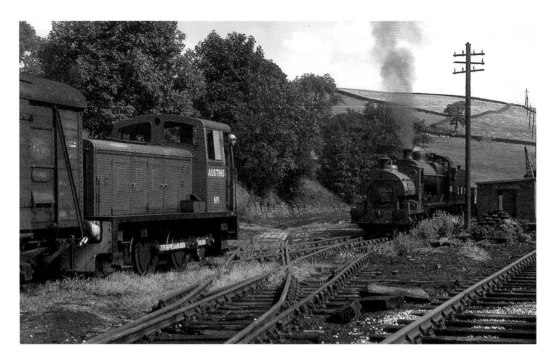

The Goods Shed and Yard at Oakworth

As you enter Oakworth station, you pass the goods yard and goods shed. In the early days of preservation in the 1970s, Peckett *North Western Gas Board* in WVR livery and LMS 4F 0-6-0 No. 43924 are shunting while Austin's No. 1 Diesel Shunter waits its turn (courtesy of C. G. Smyth/KWVR Archive). This area now acts as the railway's permanent way yard. This is a working yard, but still retains its period character, as can be seen in the pictures below and on the next page. In the picture below, BR Class 37 locomotive No. 37264 passes chairs and other rail components piled up by the edge of the yard in April 2013.

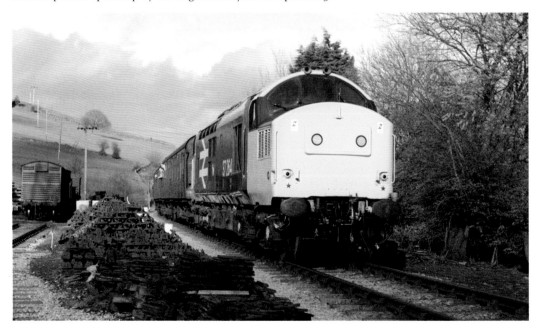

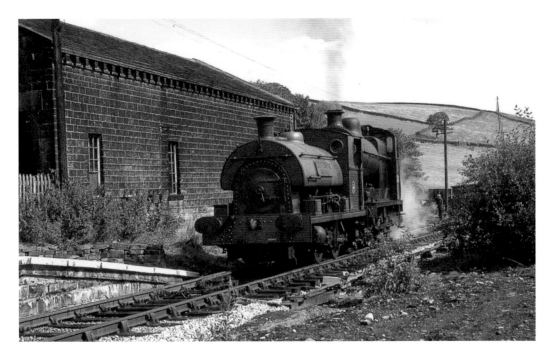

Entering Oakworth

Two of the locomotives from page 36, the Peckett and the 4F, are passing the goods shed and running into the platform in the photograph above (C. G. Smyth/KWVR Archive). In the October 2011 picture below, we see Standard 4 Tank No. 80002 heading downhill away from Oakworth station and passing the goods shed with a train for Keighley. This timeless image could so easily be from the 1950s.

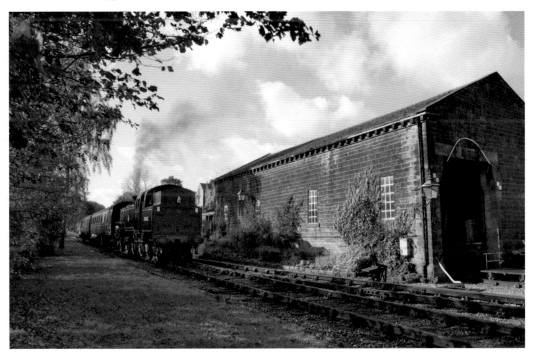

Oakworth

Just past the goods shed are a couple of sidings and a loading bay behind the platform. The picture above shows this area in the 1970s with deep snow all around. The more recent picture below is more reminiscent of the 1960s. Period wagons are used as a static display in the bay line.

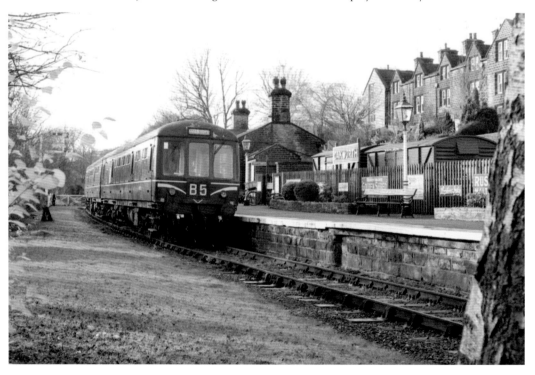

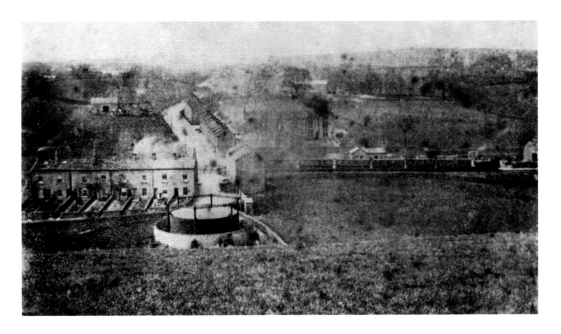

Oakworth Station

Oakworth station was made famous when *The Railway Children* was filmed there in 1970. The next few pages make an interesting comparison of the station throughout the years. The very early picture above (Robin Longbottom/KWVR Archive) shows the station in 1885–90. Note the gas holder in the foreground. Other things to note are the houses around the level crossing area and the edge of the goods shed to the far right. The April 2013 picture below shows how little the area around the level crossing has changed in the intervening years.

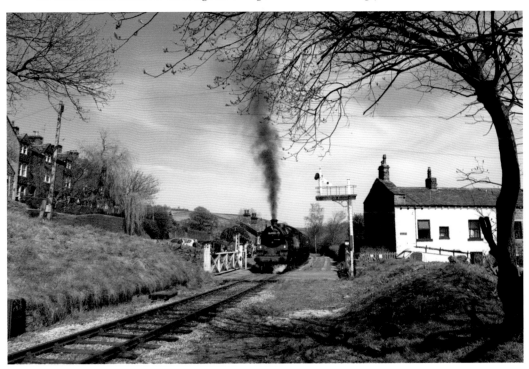

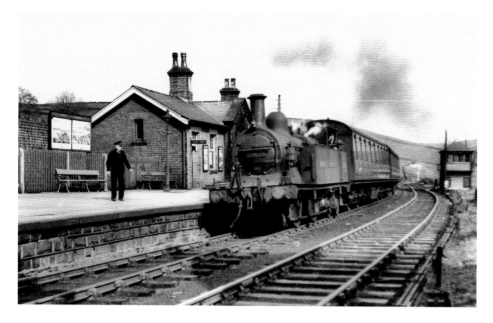

Oakworth Station

Above: By the 1950s, signs of decline are starting to show, with a Midland 0-4-4 tank looking dirty and work worn. The station itself, however, still retains much of its character. Note the signal box on the right; in preservation this was removed, with the new box being located at Damems Loop (courtesy of N. E. Stead/KWVR Archive). *Below:* In July 2011, the station looks resplendent, beautifully restored and maintained. Leaving with a train for Oxenhope is newly restored 4F No. 43924 with recently restored vintage coaches. This is a beautiful, if somewhat rose-tinted, recreation of a 1950s branch line station.

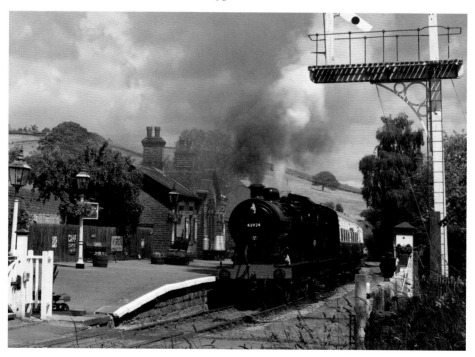

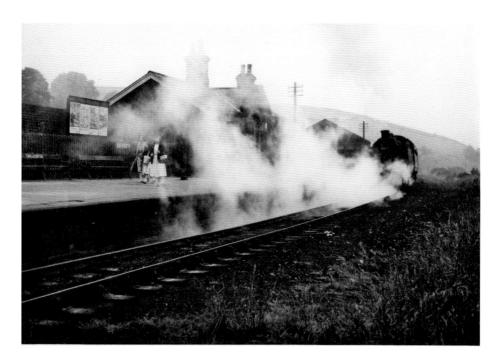

Oakworth Station

By the late 1950s, the decline was becoming more evident. The picture above from August 1957 shows Ivatt Class 2MT No. 41273 departing from Oakworth station in push-pull, with the engine at the rear of the set. Note also that the passing loop and signal box have now been removed (courtesy of John A. Pitts/KWVR Archive). The picture below shows the station immediately prior to preservation in September 1965, with an overgrown track and a very neglected station. Even in full sunshine the place looks very neglected and sorry for itself.

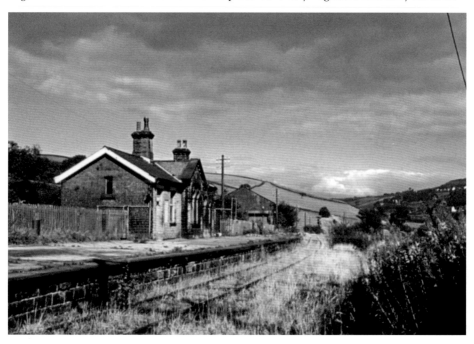

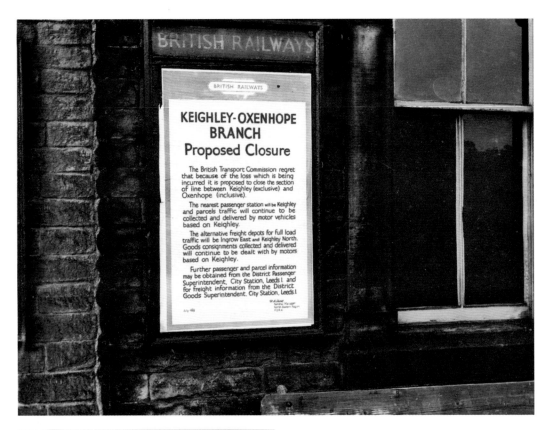

KEIGHLEY-OXENHOPE
BRANCH
Proposed Closure

The British Transport Commission regret that because of the loss which is being incurred it is proposed to close the section of line between Keighley (exclusive) and Oxenhope (inclusive).

The nearest passenger station will be Keighley and parcels traffic will continue to be collected and delivered by motor vehicles based on Keighley.

The alternative freight depots for full load traffic will be Ingrow East and Keighley North. Goods consignments collected and delivered will continue to be dealt with by motors based on Keighley.

Further passenger and parcel information may be obtained from the District Passenger Superintendent, City Station, Leeds 1 and for freight information from the District Goods Superintendent, City Station, Leeds 1

Oakworth: The Details

In the picture of the proposed closure notice from 1959 above (courtesy of John A. Pitts/KWVR Archive) there is a feeling of a run-down place. The building is dirty, the window and bench have worn and peeling paint and even the British Railways sign is badly faded. Although this is a close-up image, you can imagine the wider picture of decline and decay. Compare this with the picture below from April 2013. Michael Portillo was filming at Oakworth station for his latest *Railway Journeys* series. He kindly agreed to pose for a photograph inside the waiting room. The place now has a warm, welcoming feel, with lots of period charm.

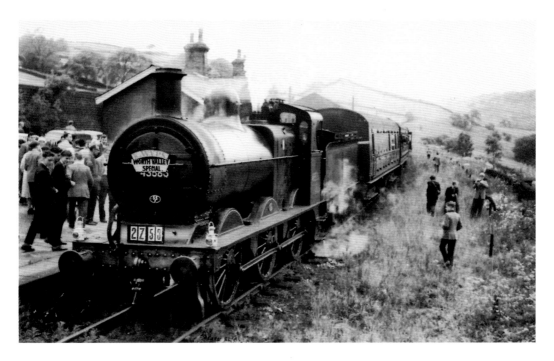

Oakworth

On the very last day of service prior to closure, a special train was run to mark the occasion. Headed by LMS 0-6-0 No. 43586, the Worth Valley Special can be seen surrounded by enthusiasts at Oakworth station on 23 June 1962 (courtesy of E. A. Wood/KWVR Archive). By 3 April 2011, with regular steam services running, the perfect branch line scene has been created as LMS Jinty No. 47279 heads out of Oakworth with a service for Oxenhope.

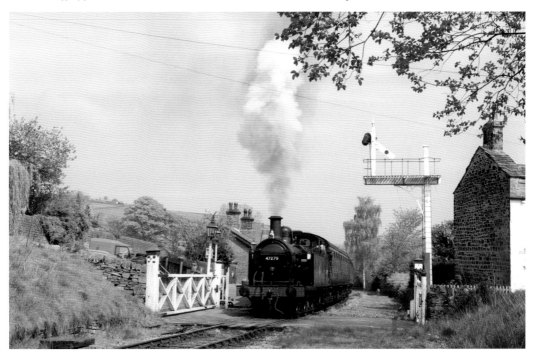

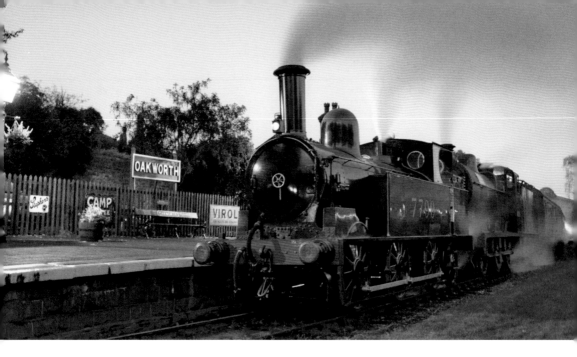

Oakworth

Dereliction is now very much a thing of the past. The station is fully restored and immaculately maintained throughout. The gas lighting adds to the period charm at Oakworth. The picture above from October 2012 should not have been possible, but escaped cows in Mytholmes Tunnel caused long delays and running into the evening. LNWR Coal Tank No. 7799 and LMS 4F No. 43924 simmer in the twilight as they await a late departure. On gala weekends, goods trains are recreated. Below we see WD 2-8-0 leaving Oakworth with an early morning mixed goods train in March 2013. In pre-preservation times, goods traffic was always an important source of income, and ultimately its decline was the main reason for closure of the branch.

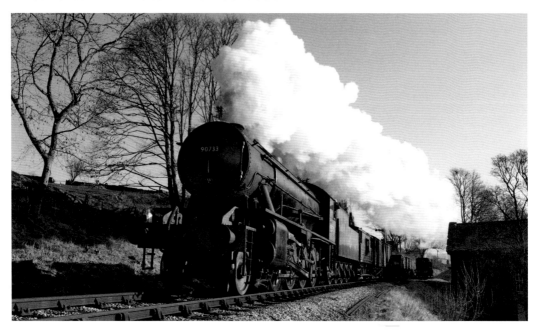

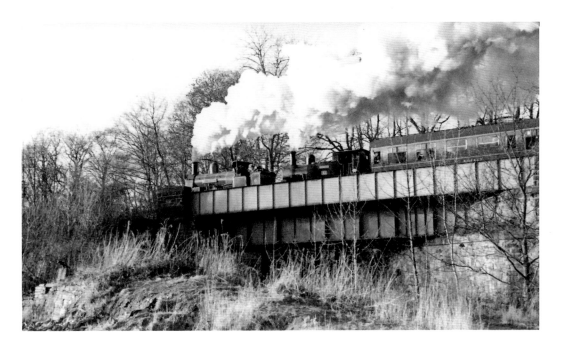

Mytholmes

Beyond Oakworth, trains climb a short embankment, passing mill buildings before crossing bridges 16, 17 and 18. This area was made famous in *The Railway Children* film as the location where the girls waved their red petticoats to stop the train. The bridges became seriously damaged in the early part of the twenty-first century. Fortunately, the £250,000 needed for the repairs was raised, with the work being completed in 2013. Had this money not been raised, the railway would have effectively been cut in half. This area can be seen in the picture of Haydock Foundry 0-6-0WT *Bellerophon* and MSC Tank No. 31 from the 1980s above (courtesy of Mr G. N. Smith/KWVR Archive), and in the February 2012 picture of the Ivatt tank at bridge 17 below.

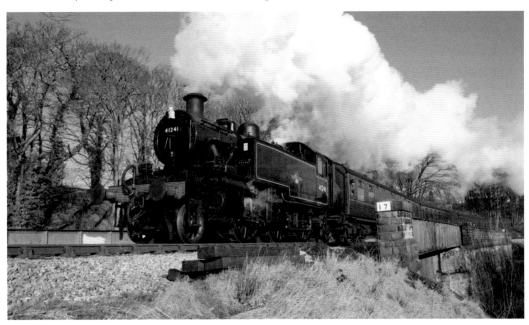

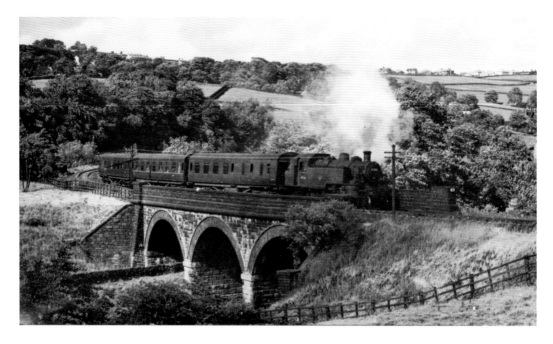

Mytholmes Viaduct

Beyond bridge 17, the railway crosses the three-arch span of Mytholmes Viaduct. The picture above from the late 1950s shows Ivatt Class 2MT 2-6-2T No. 41326 crossing the viaduct with a three-coach service for Oxenhope (courtesy of P. Wilson/E A Wood/ KWVR Archive). This is the same class of locomotive as the previous shot at bridge 17. Taken in June 2013, the picture below shows LMS 4F No. 43924 with a five-coach service at the same location. With the exception of colour on the more recent photograph, there is little evidence of any changes at the location during the intervening fifty to sixty years.

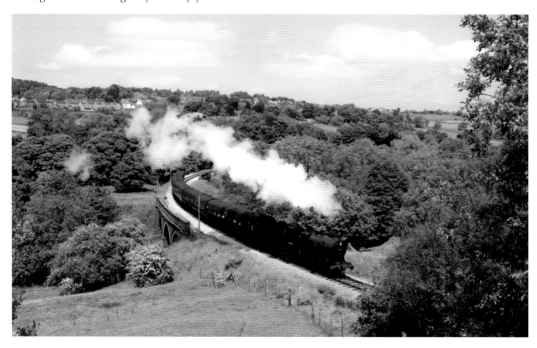

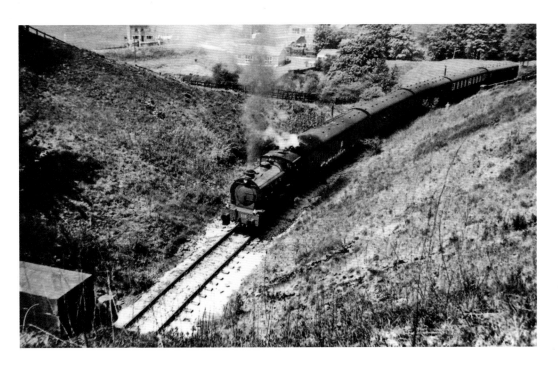

Mytholmes Cutting

Having crossed the viaduct, the line curves around and enters a short cutting on the approach to the northern portal of Mytholmes Tunnel. This 1970s picture, taken from the top of the tunnel, sees Austerity o-6-oST No. 118 *Brussells* about to enter the tunnel (courtesy of Robin Higgins/KWVR Archive). This was the scene of the landslip in *The Railway Children* film. Each year aspects of the film are recreated. In April 2013, the *Scotch Flyer* rounds the curve and enters the cutting.

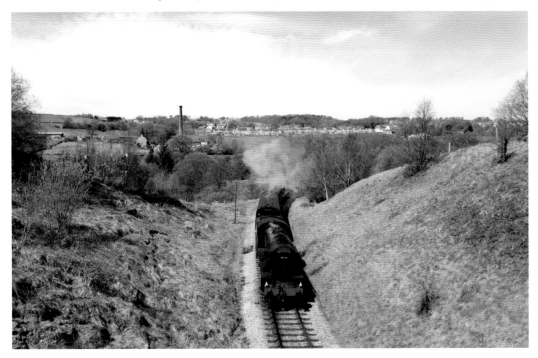

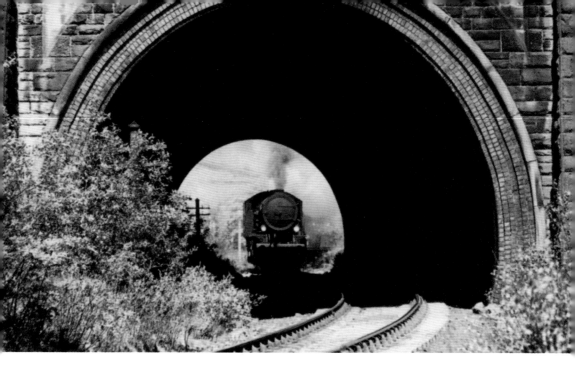

Mytholmes Tunnel

Above: Looking through Mytholmes Tunnel in the 1970s, War Department 2-8-0 No. 1931 is about to enter the tunnel (courtesy of Robin Higgins/KWVR Archive). *Below:* In beautiful conditions, War Department 2-8-0 locomotive No. 90733 bursts out of Mytholmes Tunnel with a post-Christmas 'Mince Pie Special' train on 29 December 2013. This is a busy period for the railway, with trains running every day from Boxing Day until Sunday 5 January in 2013/14.

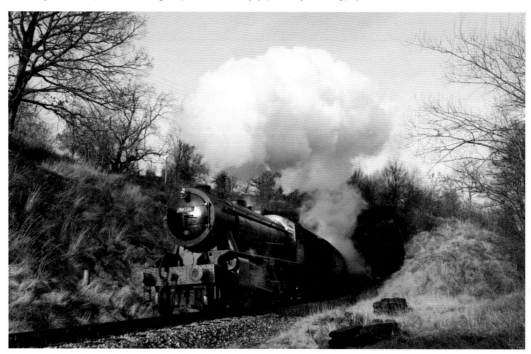

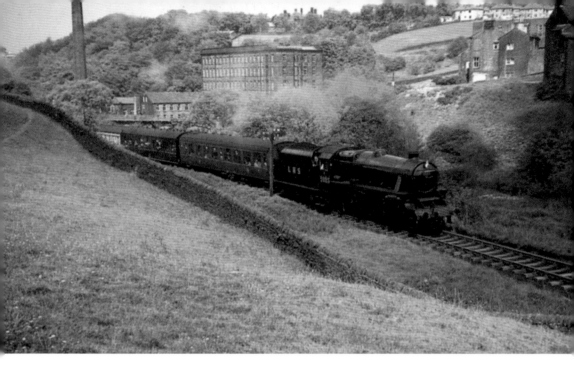

Ebor Lane and Trotsky's Bridge

A lovely shot from the 1960s sees LMS Black 5 No. 5025 approaching Ebor Lane with a service from Keighley (courtesy of J. Phillips/KWVR Archive). On a cold, sunny day, Class 37 Diesel No. 37075 rumbles through Trotsky's Bridge with the return first 'Santa Special' of the season on 30 November 2013. No. 37075 was top-and-tailed with LMS Black 5 No. 45305 to avoid the need for running round, thus saving a lot of time on a busy service. Santa Special trains are very popular, usually being fully booked well in advance. As such, they provide a valuable income for the railway as well as attracting the enthusiasts of the future.

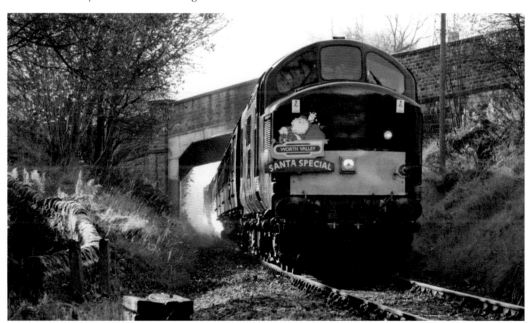

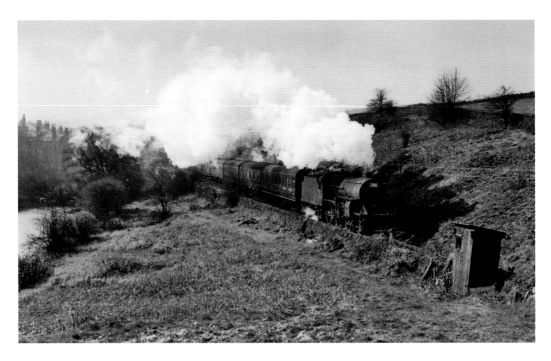

Approaching Haworth

On the approach to Haworth from north and south, the line is a mixture of terraced housing, old mills and rugged countryside. Recently, one or two of the mills have been demolished, being replaced by modern industrial units. Above, in 1961, an unidentified LMS Crab 2-6-0 heads a special for Morecambe just north of Haworth (courtesy of P. Sunderland/KWVR Archive). Below, Ivatt Class 2MT 2-6-2T No. 41241 banked, by BR Class 25 Diesel No. 25059, negotiates the icy conditions just south of Haworth on 5 February 2012.

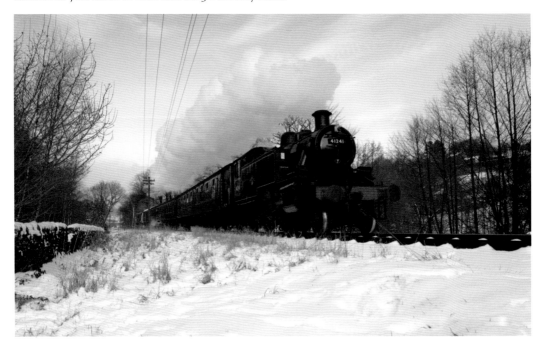

Haworth Approach

In August 1959, Ivatt Class 2MT 2-6-2T No. 41325 heads away from Mytholmes towards Haworth with a train from Keighley (courtesy of John A. Pitts/KWVR Archive). More recently, LMS Stanier Mogul 2-6-0 No. 42968 approaches Haworth with a train for Oxenhope.

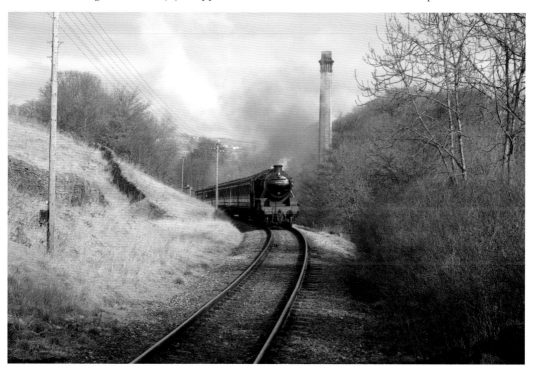

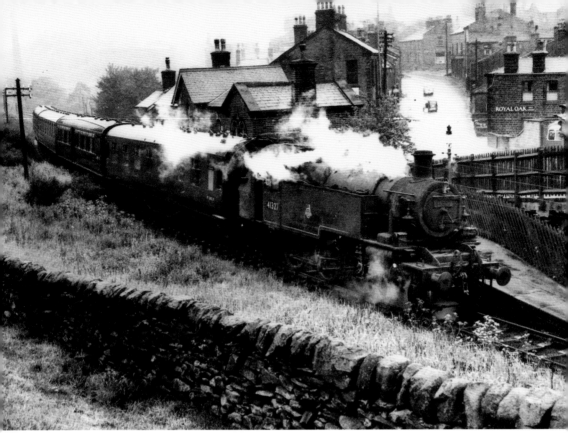

Haworth

Above: Ivatt Class 2 No. 41327 working in push-pull mode at the rear of a gala day service heading for Keighley in June 1962. This photograph gives a good general view of Haworth station in the 1960s. However, it is of greater interest due to the train formation. The second coach with the centre door was reported to have come from Rose Grove, but was actually from the LNWR Delph Branch (courtesy of P. Sunderland/KWVR Archive).

Below: In 2005, L&Y *Ironclad* No. 957 heads into Haworth on a frosty December morning. This locomotive came to the railway in 1965 and starred as *The Green Dragon* in the film *The Railway Children*. Out of traffic since 1975, the locomotive was given a £150,000 overhaul and returned to service in 2001. The locomotive went out of service in early 2013 and is now awaiting overhaul.

Haworth

Another picture at Haworth from 1962 sees Ex-LMS 3F No. 43586 with the Worth Valley Special on 23 June 1962. Taken from the top of the footbridge, you can see the crowds lining the bridge (courtesy of Keith Preston/ KWVR Archive). The picture below was taken from beneath the same bridge. Black 5 No. 45212 heads towards Oxenhope with an evening service in October 2011. This locomotive is famous as the last steam locomotive to run on the national network. It has spent most of 2013 on the main line and has been used in a recreation of the famous '15 Guinea Special' steam service.

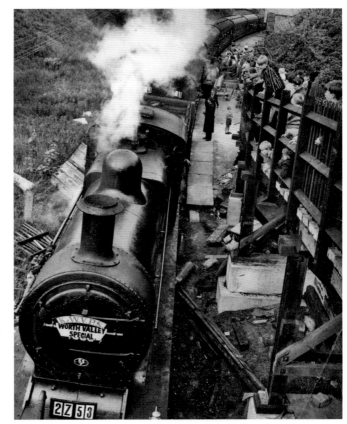

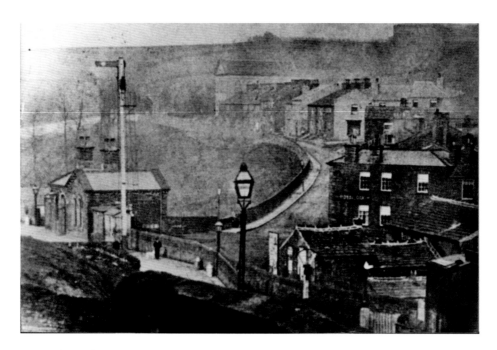

Haworth Station

The picture above shows Haworth station before 1900. The footbridge had not been built at this stage, and neither had the Conservative Club nor the row of shops to the left of the road. Note also the unusual signal (courtesy of KWVR Archive). By the early 1900s, the area around the station had seen some significant development, as can be seen below. The footbridge has still not been built, but the Conservative Club and shops are now present. Note also that the unusual signal has disappeared. The way that people are dressed is also interesting (courtesy of KWVR Archive).

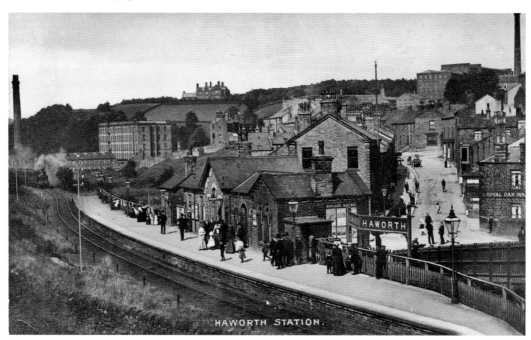

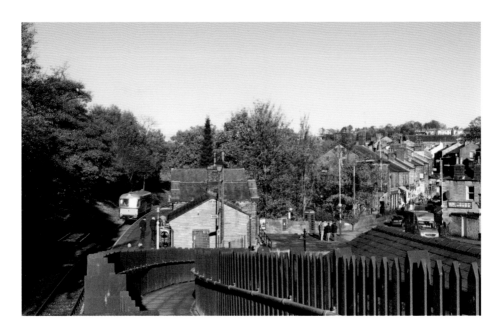

Haworth Station Area

The picture above shows Haworth station and the surrounding area in recent times. Taken in 2013, the footbridge is prominent in the foreground; otherwise, little has changed. The Conservative Club and shops can clearly be seen. The trees around the station have now grown significantly, making it impossible to take a picture from the same angle as seen previously. The picture below dates from around 1900. Taken from Haworth Brow, it gives a nice panoramic view of the general area, showing Haworth goods shed at the bottom of the valley and the yard with coal wagons. This is a view that is difficult to replicate now due to the growth of trees and bushes throughout the foreground area.

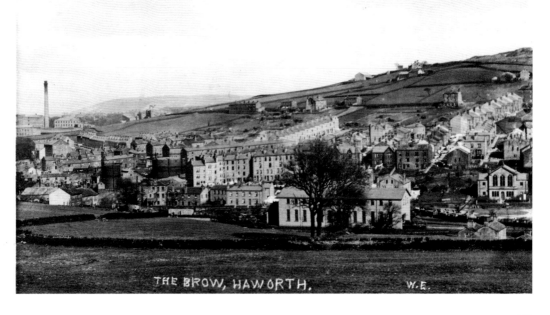

THE BROW, HAWORTH. W.E.

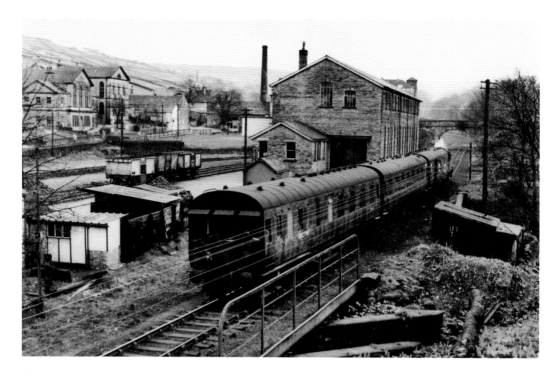

Haworth Goods Yard

Just beyond Haworth station, there was a goods yard and goods shed. The image above shows an Ivatt Class 2 push-pull fitted passing the goods shed in push mode during the 1950s (courtesy of P. B. Booth and N. E. Stead/KWVR Archive). In preservation, the goods shed became the locomotive shed. In 2005, locomotives are prepared for a gala day creating a busy steam shed scene as seen below.

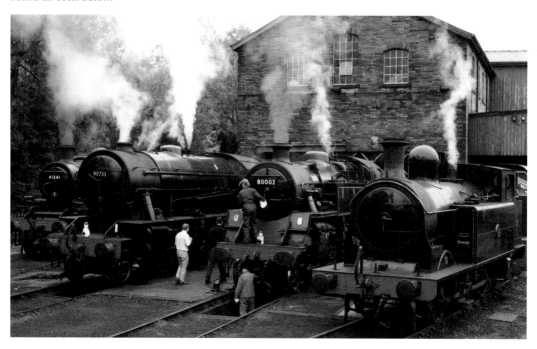

Haworth Shed

By 1958, the area around the shed is starting to look more run down. Here we see a push-pull service returning from Oxenhope passing the goods shed (R. O. T. Povey/KWVR Archive). By the 1960s, the goods yard had become abandoned and overgrown, as can be seen below (courtesy of Jack Wild/KWVR Archive).

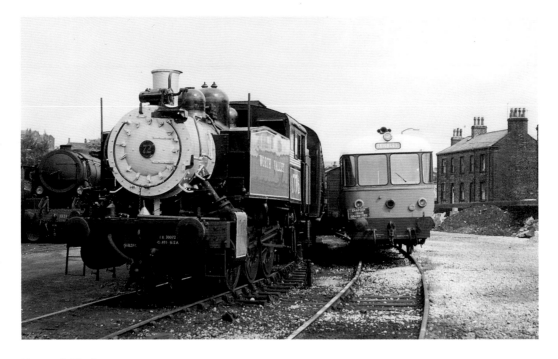

Haworth Yard

By the 1970s, the old goods yard was in use as a locomotive yard. Much of the area still needs further development, but the yard is fully functional. In the foreground, USA 0-6-0T No. 30072 wears the No. 1776 to celebrate the year that the USA won independence. Also from the 1970s, the picture below shows Haworth yard area from the opposite end with Austins No. 1 and the Ivatt Class 2MT 2-6-2T No. 41241 awaiting duties (courtesy of C. G. Smyth/KWVR Archive). It is interesting to compare the 'in-house' KWVR liveries used at the time.

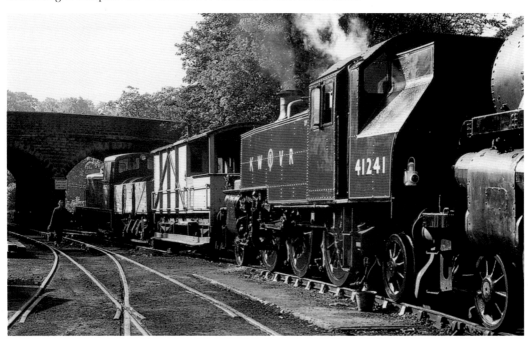

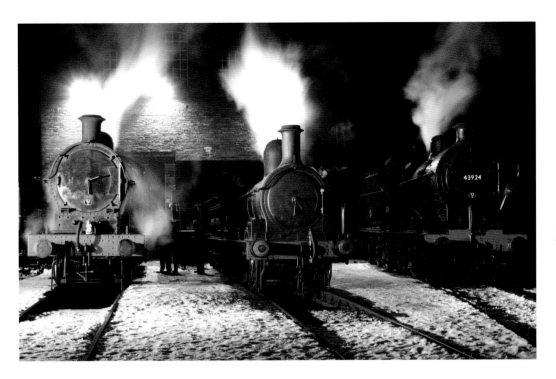

Haworth Shed

In preservation, the shed has become a locomotive shed and repair facility. At night, especially with snow laying on the ground, as in these February 2012 pictures, the shed and surrounding yard becomes a very atmospheric place. With nothing modern in the area to date the pictures, this could just as easily be 1952.

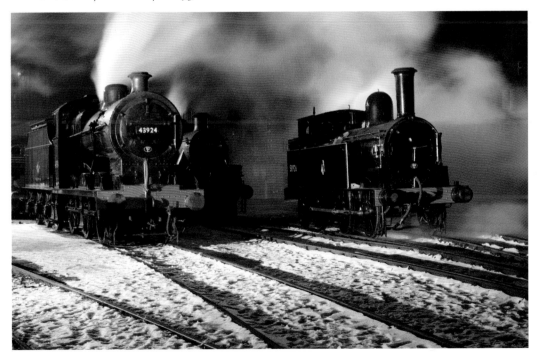

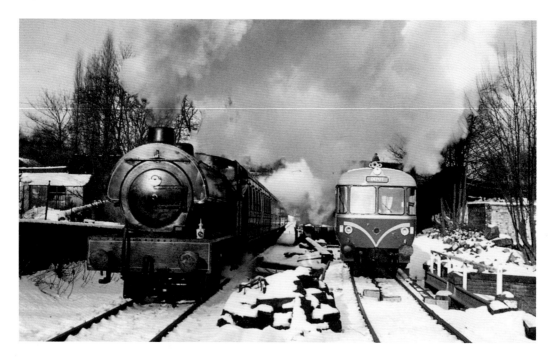

Belle Isle

Upon leaving Haworth station, the railway passes under a road bridge; the yard is also accessed at this point. In the 1970s, Austerity 0-6-0ST *Fred,* having just left Haworth station, passes under the road and crosses bridge 27, while one of the railbuses waits to enter Haworth Yard (courtesy of C. G. Smyth/KWVR Archive). Looking from the other side of the stream, the November 2013 picture of Railbus M79964 shows the same location in recent years. In the background you can see the road bridge and the yard.

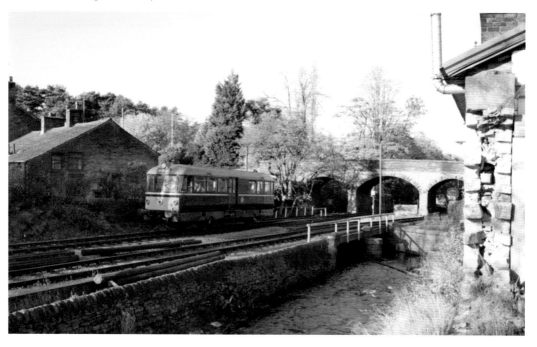

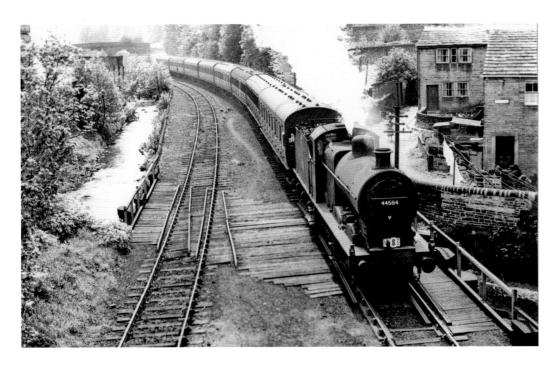

Belle Isle and Bridgehouse Beck

Beyond the road bridge, the railway crosses the river at Bell Isle. The 1958 photograph above shows ex-LMS 4F 0-6-0 No. 44584 passing Bell Isle with an Oxenhope to Morecambe excursion on Whit Monday (courtesy of P. Sunderland/KWVR Archive). From Bell Isle, the railway passes under a footbridge and passes a signal box and goods loop, running alongside Bridgehouse Beck. The picture above of Ivatt Class 2MT 2-6-2T No. 41273 passing the loop is taken from the field next to the beck sometime in the 1950s (P. Sunderland/KWVR Archive).

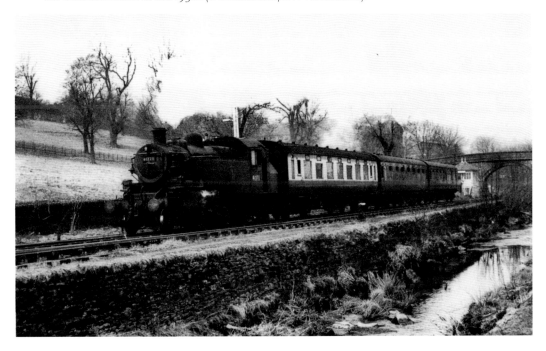

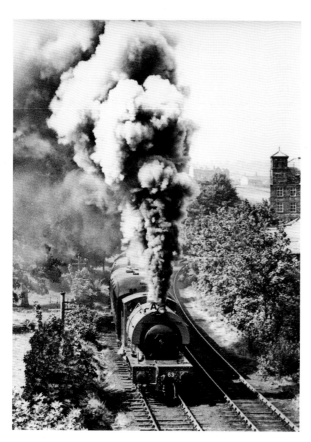

Goods Loop

Beyond the footbridge, the railway runs along the side of the beck as it heads towards Oxenhope. Taken from the top of the bridge in the 1970s, the picture above shows Stewarts & Lloyds 0-6-0ST Ugly No. 63 *Corby* passing the loop (courtesy of J. S. Clough/KWVR Archive). Since the 1970s, the flora has grown significantly, making the area look much more rural and attractive. In the 2011 picture below, L&Y *Ironclad* heads through the same location, this time taken from the side of the beck.

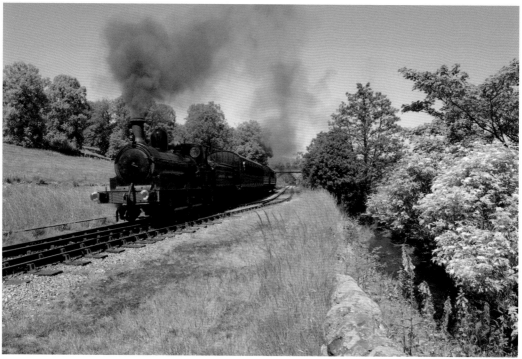

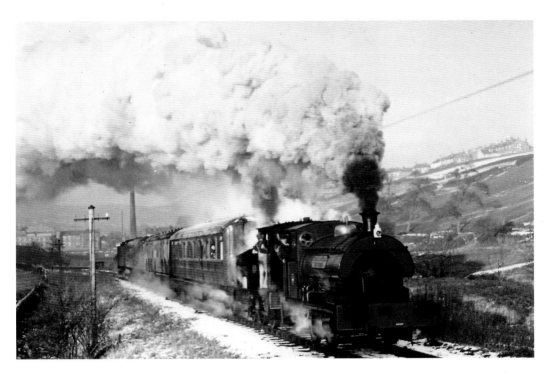

Oxenhope Straight

Above: In the early days of preservation during the 1960s, Peckett 0-4-0ST No. 1999 pilots MSC No. 67 along Oxenhope Straight. *Below:* BR Standard 4MT No. 80002 heads along the same stretch of track, watched by a couple out for a summer's stroll through this lovely part of Yorkshire.

Oxenhope Straight
Fifty-one years after the last BR train, LNWR Coal Tank No. 1054, owned by the National Trust and maintained by the Bahamas Railway Society, hauls a magnificent-looking vintage train along Oxenhope Straight on 30 June 2013. The vintage trains are made up of wooden-bodied coaches and are accompanied by a brass band at Oxenhope.

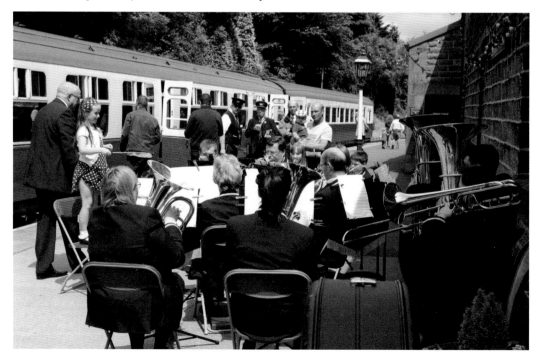

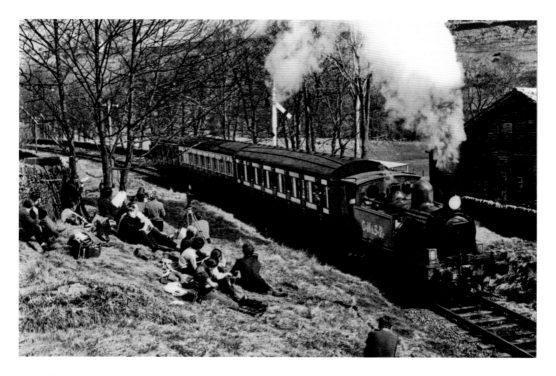

North Ives

Beyond Oxenhope Straight the line twists and turns as it heads towards Oxenhope. Before officially reopening, the area was used for the filming of the BBC television series *The Railway Children*. On 23 March 1968, J72 is filmed as it runs through with a three-coach train (courtesy of W. H. Foster/KWVR Archive). In the 1970s, ex-MSC 0-6-0T No. 67 powers a two-coach service through the same location (courtesy of N. R. Knight/KWVR Archive).

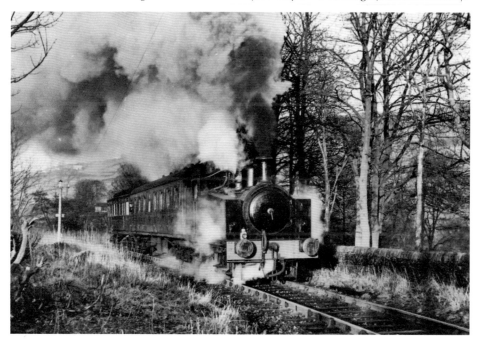

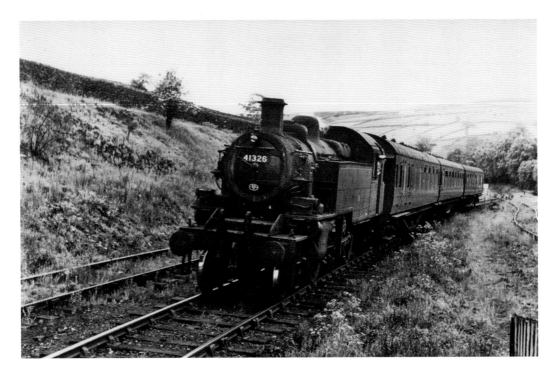

Approaching Oxenhope

Oxenhope is approached up a steep incline, as can be seen in the two images on this page. The top view, from the 1950s, shows Ivatt Class 2MT 2-6-2T No. 41326 arriving with a three-coach service (courtesy of G. Vic Nutton/KWVR Archive). Below, from July 2011, L&Y *Ironclad* No. 957 and BR Standard 4MT No. 80002 pass the ground frame once the points have been set.

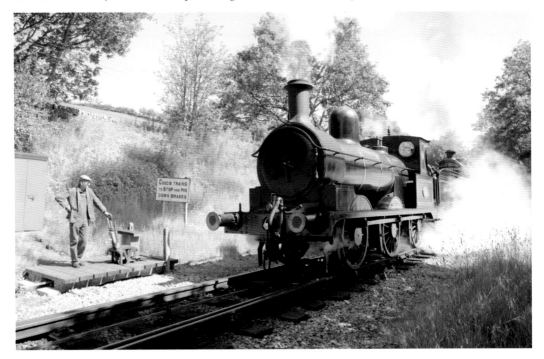

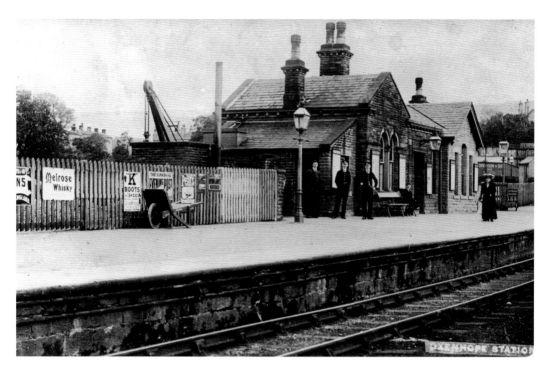

Oxenhope Station

The picture above is a deliberately posed publicity picture by the Midland Railway in the 1800s. The picture shows the station building and staff along with a female passenger walking along the platform (courtesy of KWVR Archive). Apart from showing an unusual visiting locomotive, USATC No. 5197, the 2009 picture below shows how much less formally people dress today.

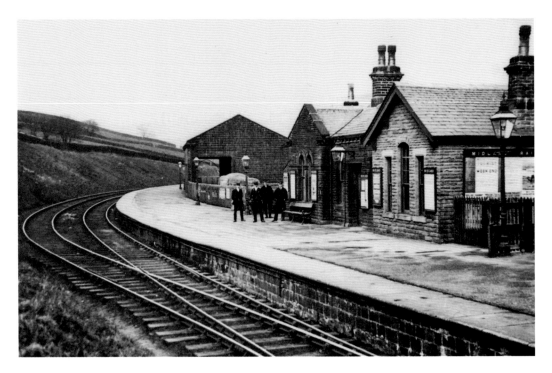

Oxenhope
Above: Station staff appear to be posing for the photograph in this view of Oxenhope station in the 1920s (courtesy of KWVR Archive). *Below:* Ex-MR Tank No. 58075 arrives at Oxenhope with a two-coach service in the 1950s (courtesy of R. A. J. Wickens/KWVR Archive).

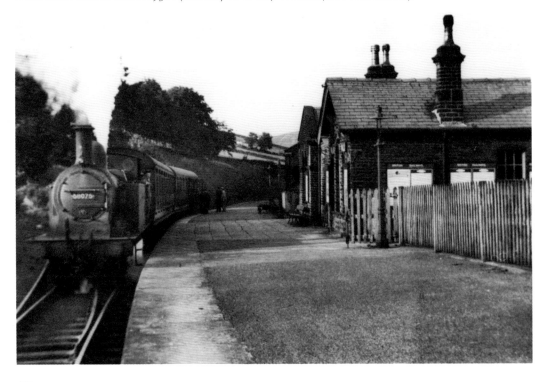

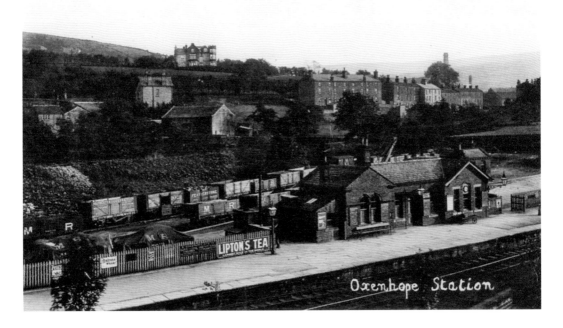

Oxenhope Station

This page provides contrasting images of Oxenhope station. The picture above dates from the 1800s and gives a good general view of the station with the yard full of coal wagons behind (courtesy of KWVR Archive). The picture below is from December 2013, with WD No. 90733 about to run round its train. Note how little the building itself has changed in well over 100 years.

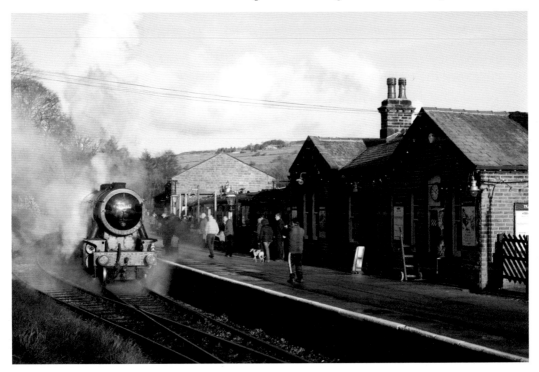

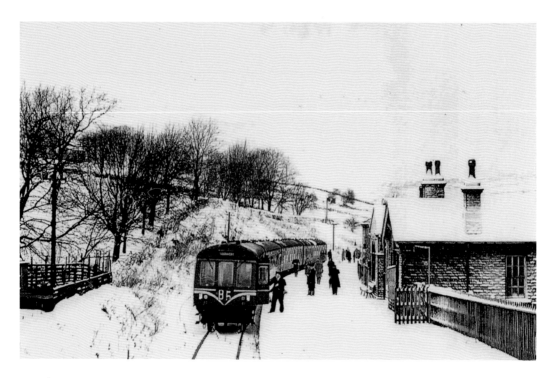

Oxenhope Station
Above: Amid very wintry scenes, a DMU arrives from Keighley on the last day of BR passenger operation on 30 December 1961 (courtesy of Ron Herbert/KWVR Archive). *Below:* In much less festive weather conditions, Class 108 DMU arrives from Keighley with a fiftieth-anniversary recreation of the last train on 30 December 2011.

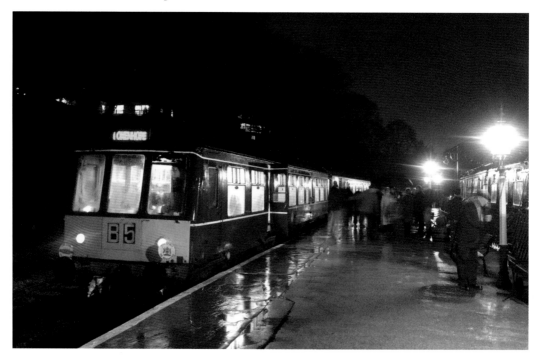

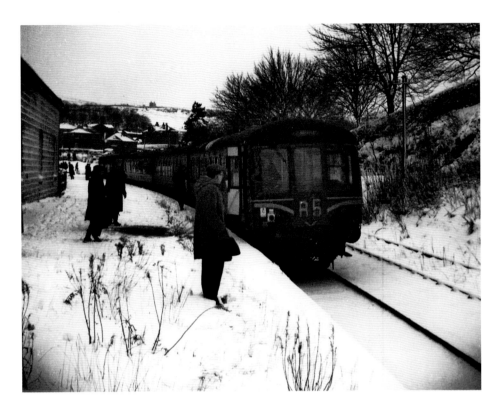

Oxenhope Station

The pictures on this page show DMUs at Oxenhope. From 1961, the picture above is another view of the last day of British Rail operations, looking towards the Headshunt and buffers (courtesy of James Shaw/KWVR Archive). Below, a Class 108 approaches Oxenhope in December 2011 on a lovely winter's morning.

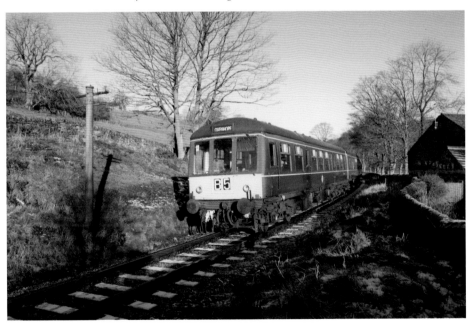

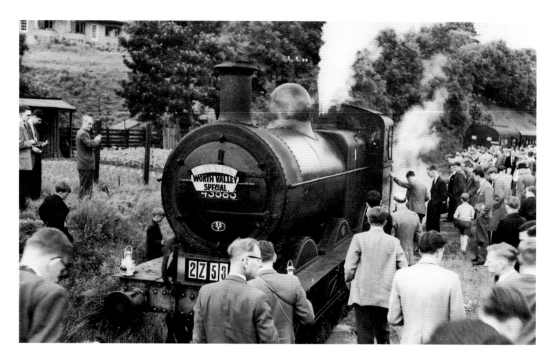

Oxenhope Station

The picture above was taken from the buffers at Oxenhope. It shows LMS 3F 0-6-0 No. 43586 about to run round the Worth Valley Special on 23 June 1962. Note the huge numbers of passengers and enthusiasts crowding the platform and station surrounds (courtesy of Eric Sutcliffe/KWVR Archive). The picture below from December 2011 shows LMS 4F No. 43924 having just arrived with a recreation of the last BR train. This important event was endorsed by the mayors of Keighley and Bradford.

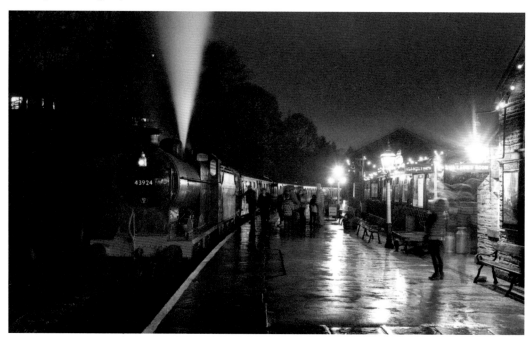

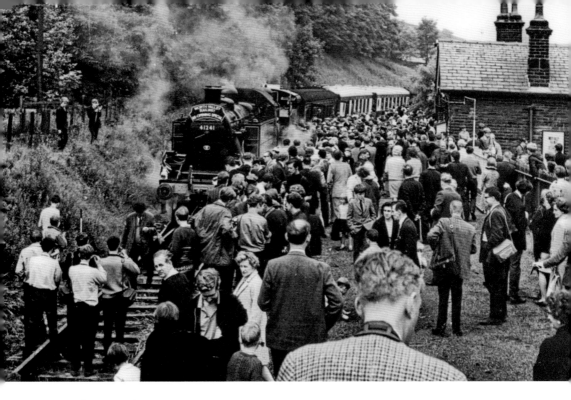

Oxenhope Station

On 29 June 1968, the railway reopened. Above is the incredible scene with hordes of enthusiasts and passengers at Oxenhope, after Ivatt Tank No. 41241 arrives with the reopening special (courtesy of K. Roberts/KWVR Archive). Below is a driver's-eye view of the approach to the station in July 2011, as a gleaming No. 957 enters the road to the carriage sheds.

Oxenhope: The Road Side

By the mid-1960s, the station looked neglected but still in fair condition. The picture above shows a general view of the approach from the road in September 1965. Note the weighbridge hut. Forty-five years later, in August 2011, everything looks better. The road and surrounds have been re-cobbled, the parking area is busy and everything is tidy and well kept. Note the two types of preserved transport, with a Black 5 in the platform and a heritage bus service in the station approach.

Oxenhope Station: Car Park

By 1986, the station approach was pretty much as it is now. On the right is the museum, with the workshops in the centre background. Although this picture is only just over twenty-five years old, the cars look very dated (courtesy of Nigel Hunt/KWVR Archive). In more recent years, the station approach has been used for a number of special events. In July 2011, it played host to a MicroCar rally. Many of the cars in the more recent picture date from a similar era to the ones in the 1980s picture.

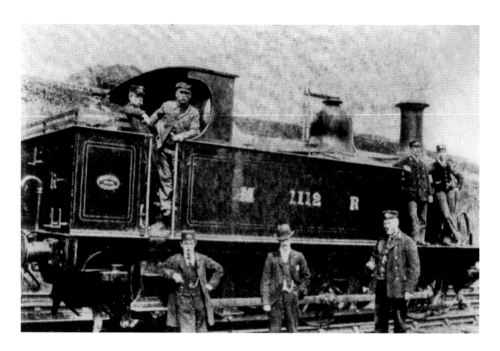

Locomotives: Pre-Preservation Locomotives

In the early days of the Midland Railway, the branch was worked by 1377 Class 0-6-0Ts. Classified as 1F, they were known as half-cabs, as they were built without a back to the cab and only had a short cab roof. The photograph above is from the 1890s and shows No. 1112 standing at Oxenhope surrounded by crew and station staff (courtesy of KWVR Archive). Because of the weather conditions in the Worth Valley, later locomotives were fitted with full cabs, as seen in the 1905 picture below. No. 1111 stands at Lawkhome Lane engine shed, Keighley. Built by Nielson & Co. in January 1875, No. 1111 became No. 1629 in 1907 and was withdrawn in January 1928. The driver is Septimus Casson, who worked the branch trains for over thirty years (courtesy of V. Fattorini/KWVR Archive).

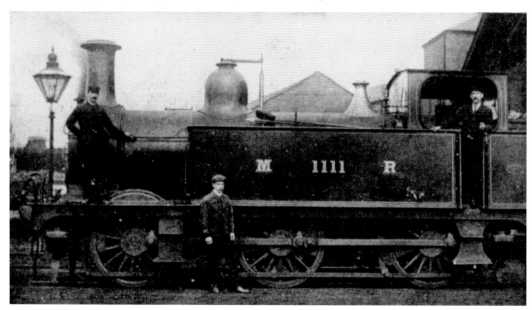

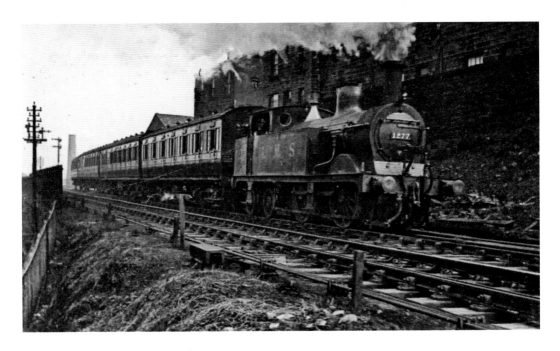

Pre-Preservation Locomotives

In LMS days, the Johnson 0-4-4Ts regularly worked the branch. In the picture above, No. 1532 Class 1277 hauls a four-coach train away from Keighley. This is an example of a non-Belpaire-boilered locomotive that is not fitted for push-pull working (courtesy of KWVR Archive). In later BR days, Class 3 0-6-0s were used especially on goods trains. The picture below shows No. 43586, the last BR train to run on the branch at Oxenhope Straight, with the Keighley & Worth Valley Railway Preservation Society (KWVRPS) special on 23 June 1962 (courtesy of R. S. Greenwood/KWVR Archive).

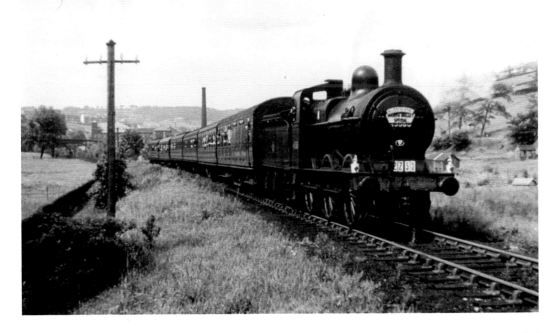

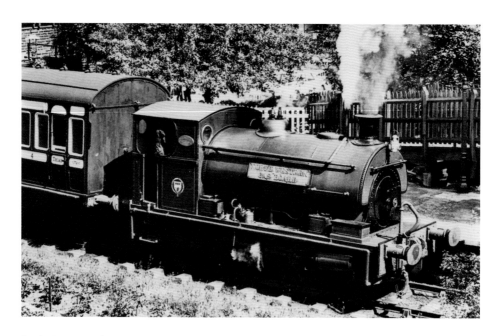

Early Preservation Days

In the 1960s and '70s, much of the motive power was provided by small industrial tank locomotives. The pictures on this page are typical examples of the type of locomotive used. Above, Peckett 0-4-0ST No. 1999 waits at Haworth station. Acquired from Darwen Gasworks in 1966, the locomotive proved unsuitable for the KWVR. It has now been purchased by the Ribble Steam Railway. Although more powerful, Stewarts & Lloyds 0-6-0ST Ugly No. 57 *Samson,* seen below, also proved unsuitable and was sold to the Spa Valley Railway (courtesy of C. G. Smyth/KWVR Archive).

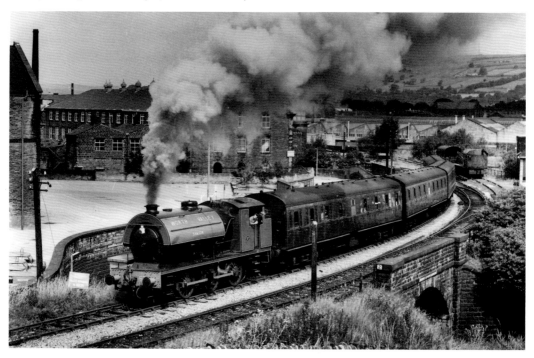

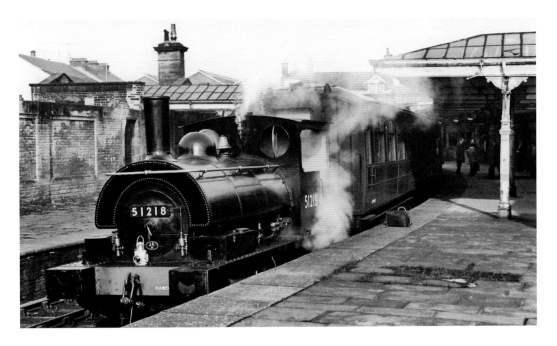

The Early Days

Another small tank that worked on the line during the 1960s and 1970s was Lancashire & Yorkshire Railway Pug 0-4-0ST No. 51218. In this photograph from the 1960s, the Pug stands in Keighley station. Currently out of service, this locomotive is still based at the railway (courtesy of KWVR Archive). Some of the more powerful industrial locomotives were the Austerity 0-6-0STs. The photograph below makes an interesting comparison, on the left is Austerity Tank *Fred* piloting an LMS Black 5. On the right is the diminutive 0-4-0ST *Lord Mayor*, now on static display in the VCT Museum at Ingrow (West) (courtesy of KWVR Archive).

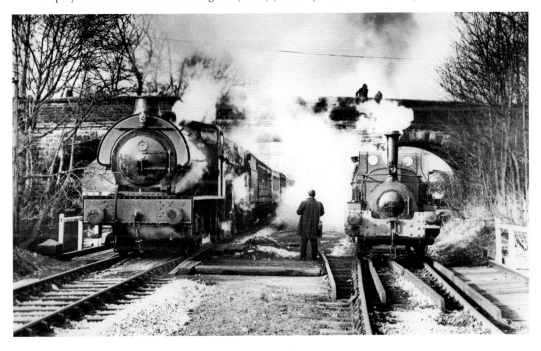

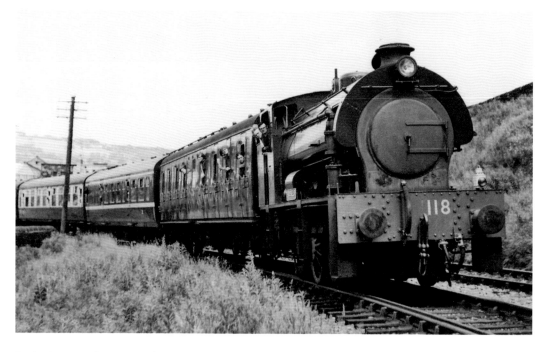

Early Preservation Days: The Austerity Tanks

The KWVR was home to a number of Austerity 0-6-0STs during the first decade of preservation. Above we see No. 118 *Brussells* starting up Keighley Bank (courtesy of KWVR Archive). This locomotive is still based at the KWVR and is currently on static display. Below is a typical yard scene from the 1970s, with Austerity 0-6-0ST *Fred* standing in front of a Stewarts & Lloyds 0-6-0ST (courtesy of C. G. Smyth/KWVR Archive). *Fred* is now part of the Somerset & Dorset locomotive collection and is in storage at Tyseley.

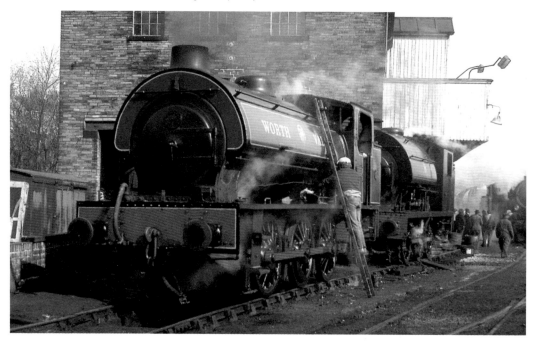

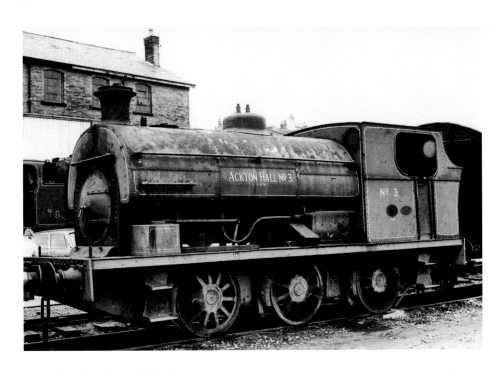

Ex-National Coal Board Tanks

A locomotive that did not spend long at the KWVR was ex-National Coal Board Peckett 0-6-0ST No. 3 *Ackton Hall*. It was in a sorry state when it arrived at Haworth in the 1970s. The locomotive was subsequently moved to the National Mining Museum (courtesy of Nigel Hunt/KWVR Archive). In the 1950s, the same locomotive can be seen working at a colliery with pithead gear in the background (courtesy of KWVR Archive).

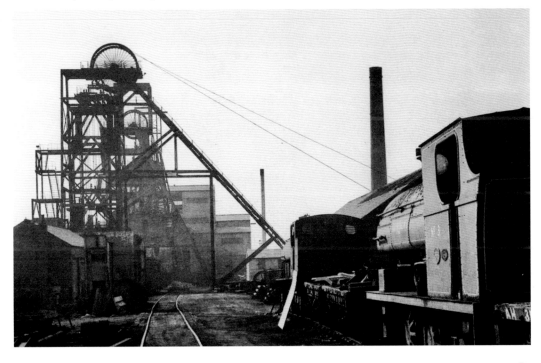

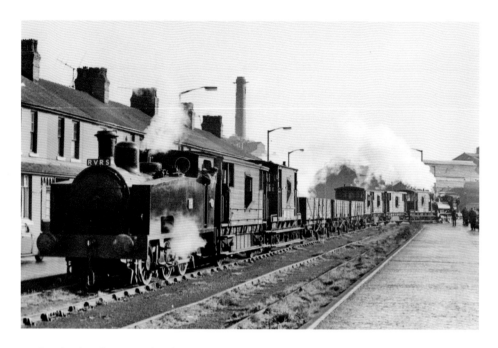

Variety in the First Decade of Preservation

Both of the pictures on this page are interesting because they show a locomotive that was used in the 1960s and 1970s with a locomotive that is still based at the KWVR. Manchester Ship Canal 0-6-0T No. 67 hauls the RVRS rail tour at the Manchester Ship Canal, banked by L&Y Pug No. 51218 in the 1960s, above (courtesy of KWVR Archive). No. 67 is now based at the Middleton Railway, while No. 51218 is still based at the KWVR awaiting overhaul. Below, Stewarts & Lloyds 0-6-0ST Ugly No. 63 *Corby* stands in Haworth Yard. Standing behind is L&Y 0-6-0ST No. 752. No. 63 is now based at the Great Central Railway, while No. 752 is based at the KWVR awaiting overhaul by the L&Y Trust.

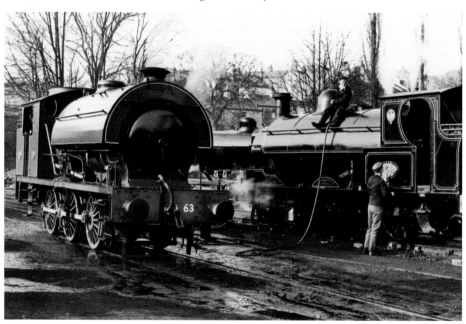

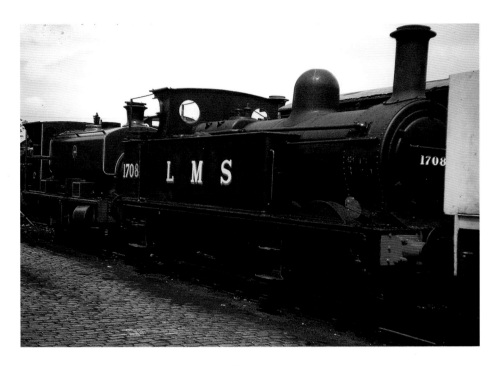

Locomotives No Longer Based at the KWVR

In 1971, LMS 1F 0-6-0T No. 1708 stands in Haworth yard. This locomotive is the only Midland Railway 1F to survive; it is now preserved at Barrow Hill Engine Shed (courtesy of J. Phillips/KWVR Archive). During the 1960s, LNER N2 0-6-2T No. 4744 was used on the KWVR. This locomotive is owned by the Gresley Society and is now preserved on the Great Central Railway (courtesy of KWVR Archive).

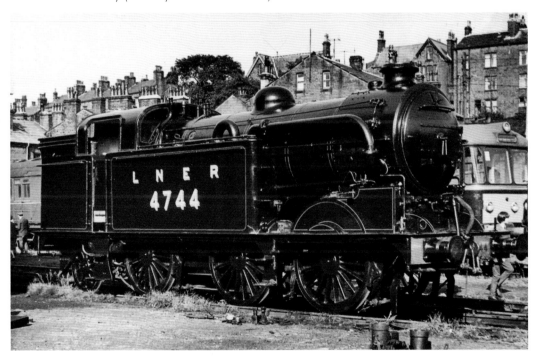

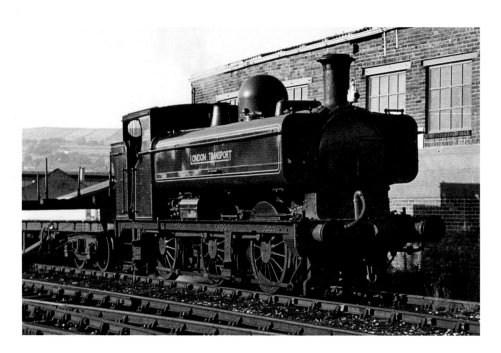

Stars of the Early Days

Above: Currently out of service, GWR 0-6-0PT No. 5775 in London Transport livery is shunting at Keighley (courtesy of C. G. Smyth/KWVR Archive). This was one of the stars of the film *The Railway Children. Below:* LNER J72 0-6-0T 69023 *Joem* was purchased by the KWVR in 1966. During its time on the railway, it also starred in the BBC TV version of *The Railway Children.* In need of re-tubing, *Joem* left in 1975 and has been used on a large number of preserved lines ever since (courtesy of C. G. Smyth/KWVR Archive).

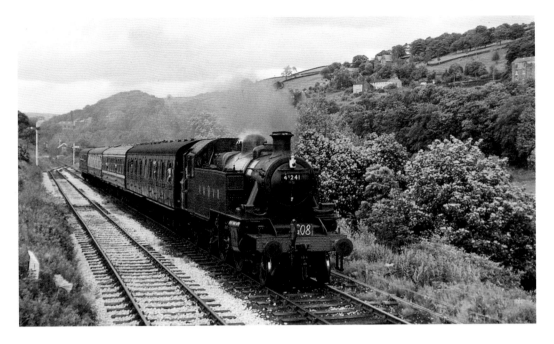

Preserved Locomotives: The Ivatt Tank

Probably the most important locomotive to work on the line is BR Ivatt 2MT No. 41241. Built at Crewe in 1949 to an LMS design, No. 41241 ended up at Skipton in 1965 and was bought from there in 1967. This locomotive hauled the train when the branch reopened in 1968. It is often referred to as the very soul of the Worth Valley Railway. Above we see it in Damems Loop in the 1970s wearing the KWVR 'in-house' livery (courtesy of C. G. Smyth/KWVR Archive). Below, wearing BR lined black, No. 41241 is passing Haworth Goods Loop on a very snowy February day in 2012.

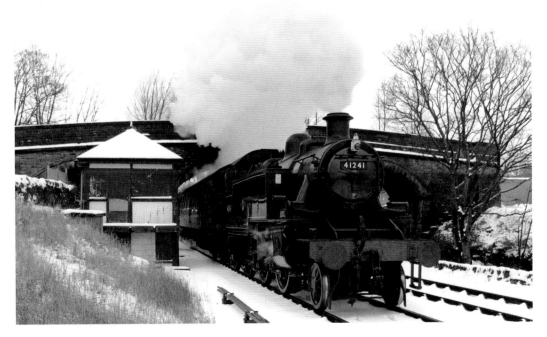

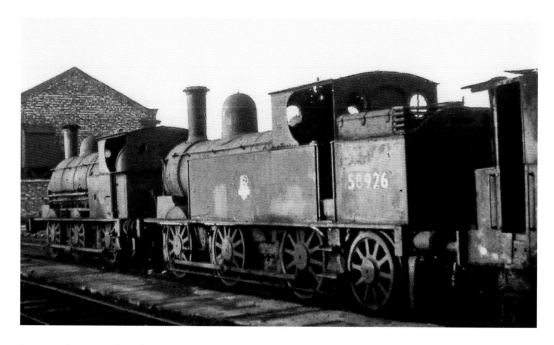

Locomotives Based at the KWVR

LNWR 0-6-2T Coal Tank No. 1054 from 1888 normally sees service on galas or on vintage train services. Owned by the National Trust, No. 1054 is looked after by the Bahamas Locomotive Society and based at Ingrow (West). The recent overhaul of this locomotive was aided by a grant from the National Lottery. When not in use on the KWVR, the coal tank regularly visits other preserved railways. In December 1959, wearing its BR No. 58926, the coal tank stands in the sidings at Crewe. In front is an L&Y Aspinall 0-6-0ST, similar to the preserved one seen on page 82 (courtesy of KWVR Archive). In 2013, No. 1054 heads up Keighley Bank with a vintage train of wooden-bodied coaches.

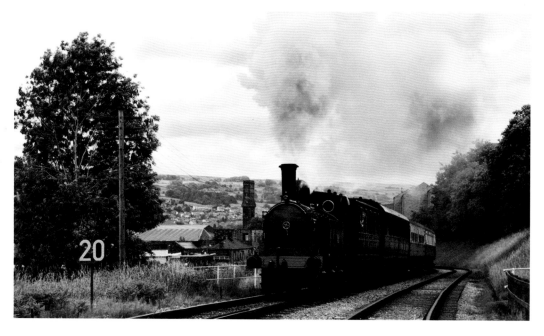

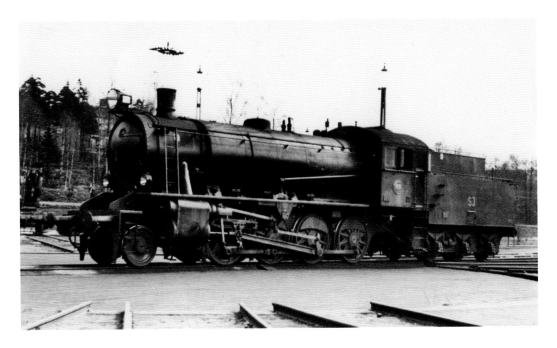

Repatriated Locomotives

Shown above is War Department 2-8-0 No. 90733. Built in 1945 by the Vulcan Foundry Ltd in Newton-le-Willows, the locomotive was sold to the Dutch Railways. From there it was sold to the Swedish State Railways in 1953 and converted to Swedish form for use in the Arctic Circle, as seen above (courtesy of KWVR Archive). Withdrawn from service in 1956, it was then stored in a forest clearing until 1972, when it was purchased by the KWVR. From the outset, the plan was to change the locomotive back to its original form, and renumber the only remaining WD 2-8-0 in the world using the series of numbers for repatriated locomotives on British Railways. The picture below shows the locomotive shortly after re-entering traffic in 2007.

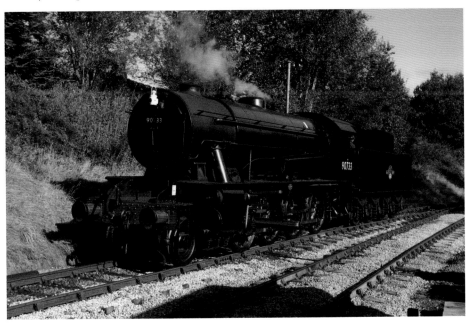

The American Locomotives

The USATC S100 0-6-0T No. 72 was used on many of the early trains on the KWVR. Built by Vulcan Iron Works in Pennsylvania, it was moved to the Southern Railway during the Second World War. No. 72 finished its working life at Southampton Docks before being bought by the KWVR. This locomotive is now on display at Oxenhope, with no current plans for overhaul. Another locomotive built in the USA for War Department use is S160 No. 5820 *Big Jim*. Returned to service in January 2014, it was painted in BR Black with the No. 95820, as seen below, for a short period before returning to its more usual USA livery.

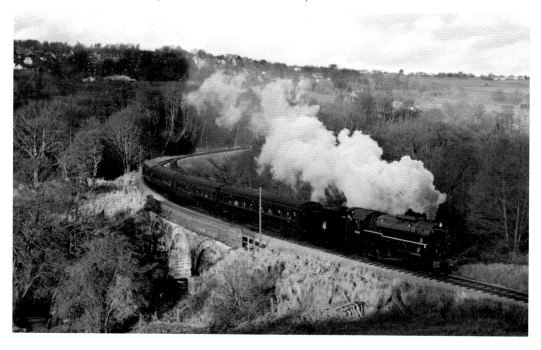

The Class 4s

A reliable and regular performer on the line is BR Standard 4MT No. 80002. Above, the locomotive heads up the incline into Damems station in April 2011. Unfortunately, this locomotive went out of service recently and is currently awaiting overhaul. Returned to steam in 2011 after an extensive overhaul, LMS 4F No. 43924 is an important member of the KWVR locomotive fleet. Built in 1920, it was the first locomotive to leave Barry Scrapyard at the end of steam, and is the only surviving true Midland 4F.

Preserved Locomotives

A locomotive that saw regular service until recently is LMS 3F Jinty No. 47279. Now out of service, there are no imminent plans for restoration. In contrast, a locomotive that is currently undergoing restoration and overhaul is Taff Vale 0-6-2T No. 85. Having hauled coal trains in South Wales, it was sold by the Great Western Railway (GWR) to a colliery in Sunderland in 1927. Although it was bought by the KWVR in the 1960s, it did not return to steam until 2000, going out of service again in 2009.

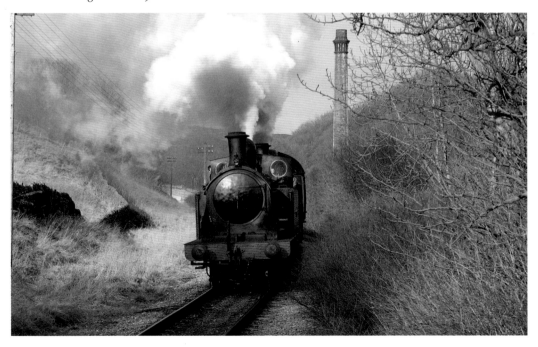

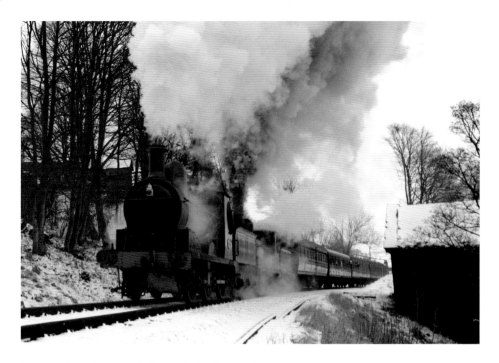

Locomotives from Both Ends of the Steam Era

L&Y *Ironclad* No. 957 is a fantastic example of a locomotive dating from the nineteenth century, entering traffic in 1887. Withdrawn from service in 1959, it came to the KWVR in 1965 and was returned to steam in 2001. The picture is from its last weekend in service, double heading with Lancashire & Yorkshire Class 27 No. 1300 on 3 January 2013. Another important locomotive is LMS Black 5 No. 45212, BR's last steam locomotive. In August 2011, it was used in a recreation of its last days on BR, as seen at Mytholmes below. Recently, No. 45212 has been working on main line specials.

The Small Tank Engines

Hudswell Clarke 0-6-0T No. 1704 *Nunlow* is the smallest steam locomotive currently based at the KWVR. Owned by the Bahamas Railway Society, *Nunlow* normally only sees service on gala weekends. Another small tank engine is Manning Wardle 0-6-0 saddle tank *Sir Berkeley*, owned by the Vintage Carriages Trust. This locomotive is currently based at the Middleton Railway in Leeds, as seen in the picture below, where it is double heading a goods train with fellow Manning Wardle *Matthew Murray*.

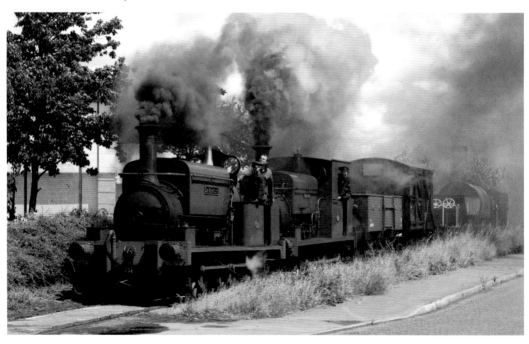

DMUs and Railbuses

The Class 101 DMU above is made up of two separate units. Nos 51803 and 51189 never worked together on the National Railway Network. Arriving from First North Western in 2003, the units have now been repainted into BR green and yellow. The other DMU on the KWVR is a Class 108 made up from units No. 50928 and No. 51565. British Railways produced railbuses to provide an economical service on lightly used lines. Produced by a variety of manufacturers, the construction used a fixed four-wheel chassis with a modified bus body. The railbuses proved to be very economical if somewhat unreliable; all were withdrawn by the mid-1960s. The KWVR has two railbuses, both built by Waggon und Maschinenbau; No. M79964 as seen below and No. E79962.

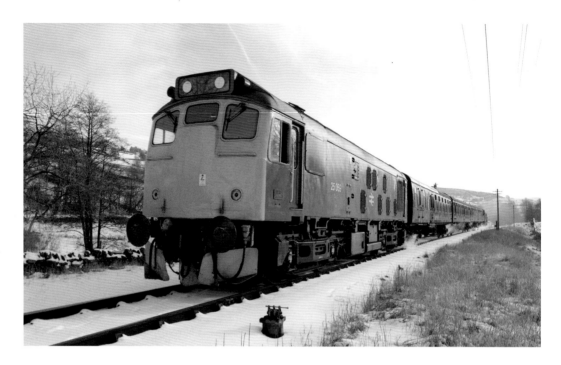

Diesel Locomotives

There are three ex-main line Locomotives at the KWVR. One of these is BR Class 25 Bo-Bo Type 2 No. 25059, as seen above. Built at Derby Works, it entered service in 1963 and was withdrawn in 1987. Another ex-main line locomotive, below, is Class 37 English Electric Type 3 Diesel Electric No. 37075. The class was used on main line passenger and heavy freight trains and proved very successful, many being rebuilt to prolong their working life. The third example is BR Class 20 Type 1 Diesel Electric Locomotive No. 20031.

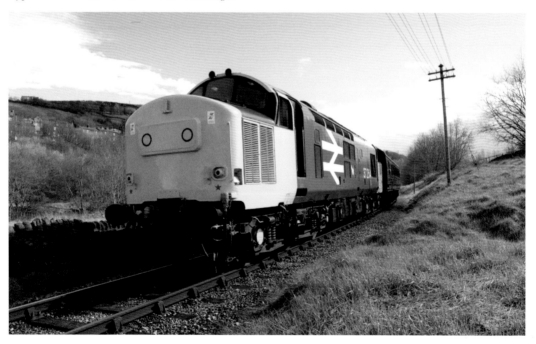

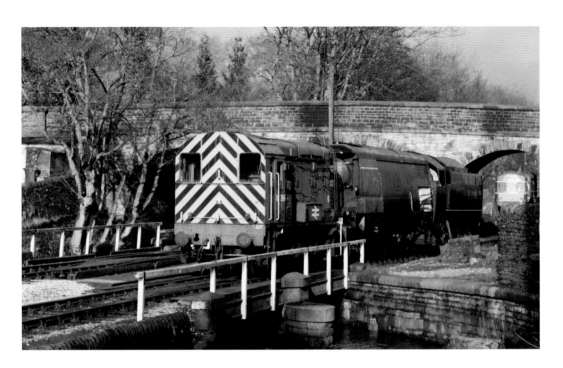

Diesel Shunters

The KWVR has a number of diesel shunting locomotives, with a number in regular use. Above is Class 08 No. 08266 shunting SR West Country No. 34092 *City of Wells* in February 2014. *City of Wells* is being overhauled for a return to service during 2014. Probably the most unusual locomotive at the KWVR is D0226. This is the only surviving locomotive of two prototype diesel shunting locomotives built by English Electric at its Vulcan Foundry in 1956. Both were 500hp, D0226 being diesel-electric, while sister engine D0227 was diesel-hydraulic.

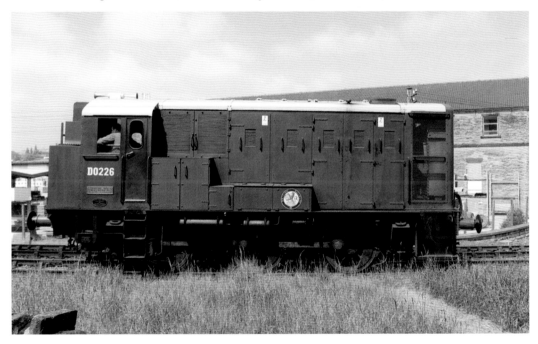

Recreation of 1950s Branch Line
The intention is to recreate a 1950s branch line. This 2013 shot of ex-Lancashire & Yorkshire Railway (L&Y) A Class, No. 1300 and BR Standard Class 4 No. 80002 double heading into Damems station could just as easily be from the 1950s.

Acknowledgements

My thanks go to my long-suffering family for putting up with me regularly disappearing to photograph the Keighley & Worth Valley Railway.

Special thanks also go to Paul Brunt, archivist at the KWVR. Without his help and patience helping to find suitable archive images, none of this would have been possible.